S0-ABB-864

VENICE

CITY OF ART

Text
Matteo Varia

Photographs
Livio Bourbon

Translation
Richard Pierce

Editing and layout
Fabio Bourbon

I.B. TAURIS
LONDON · NEW YORK

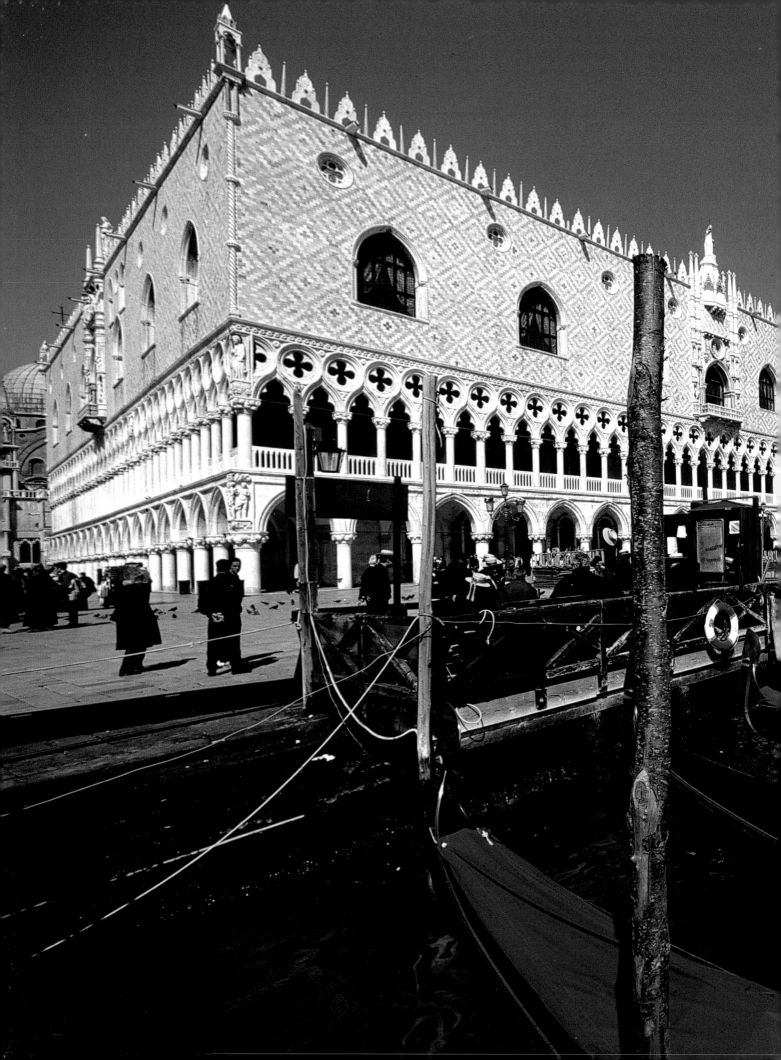

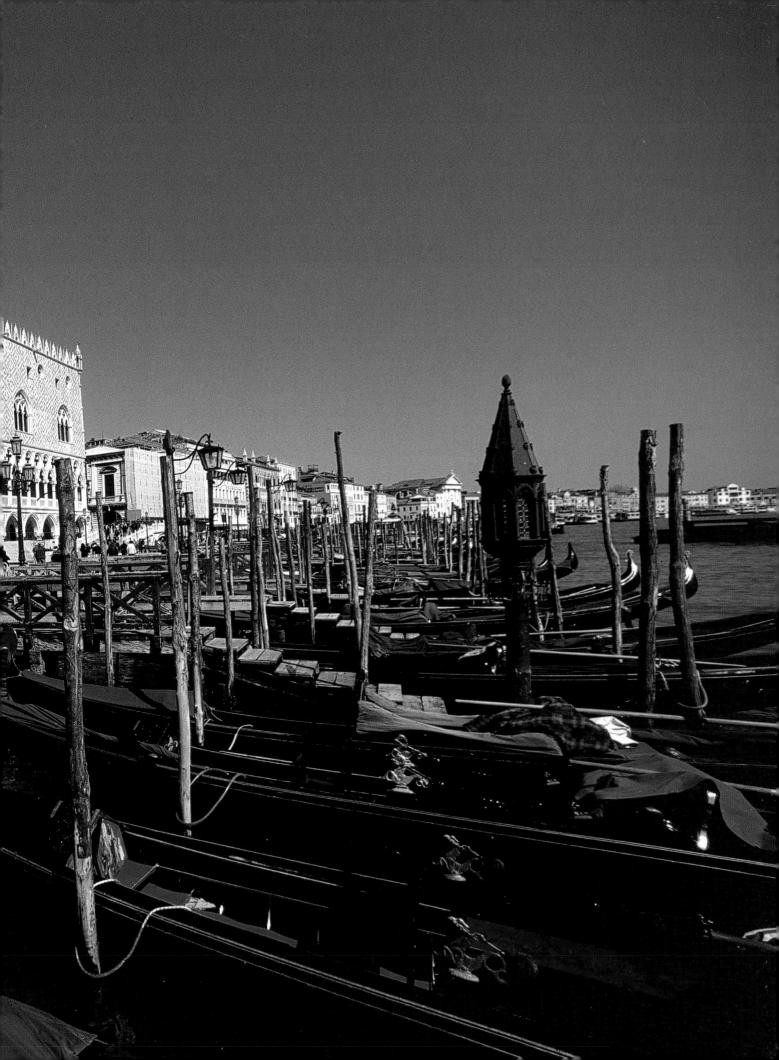

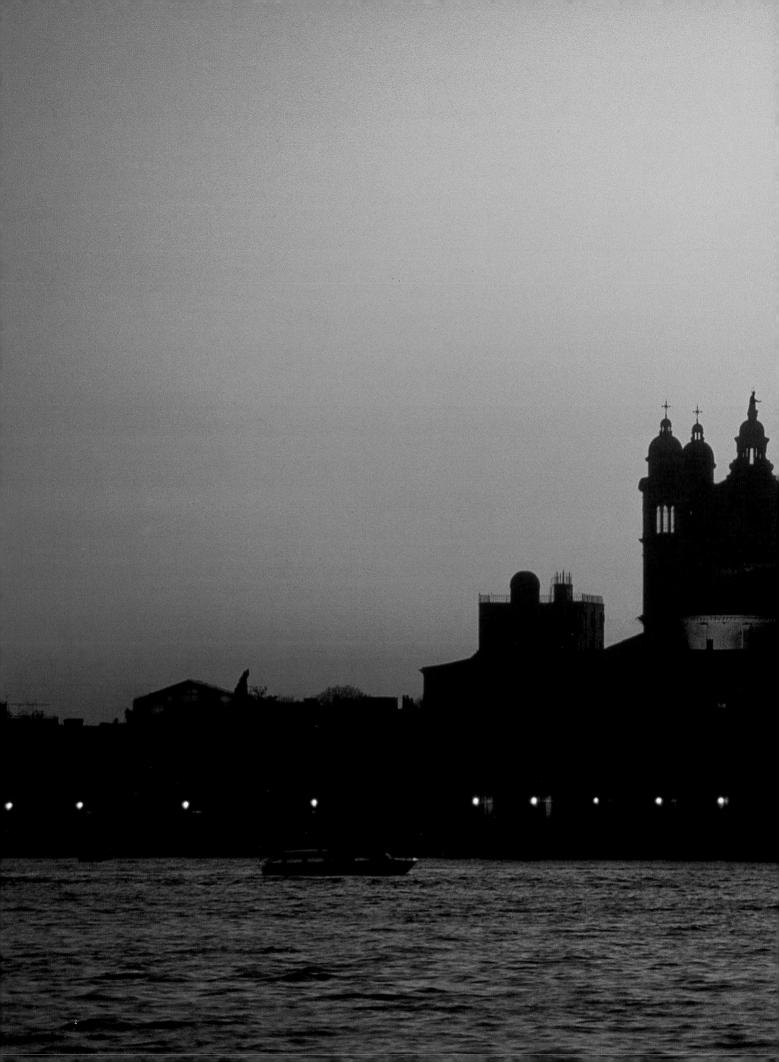

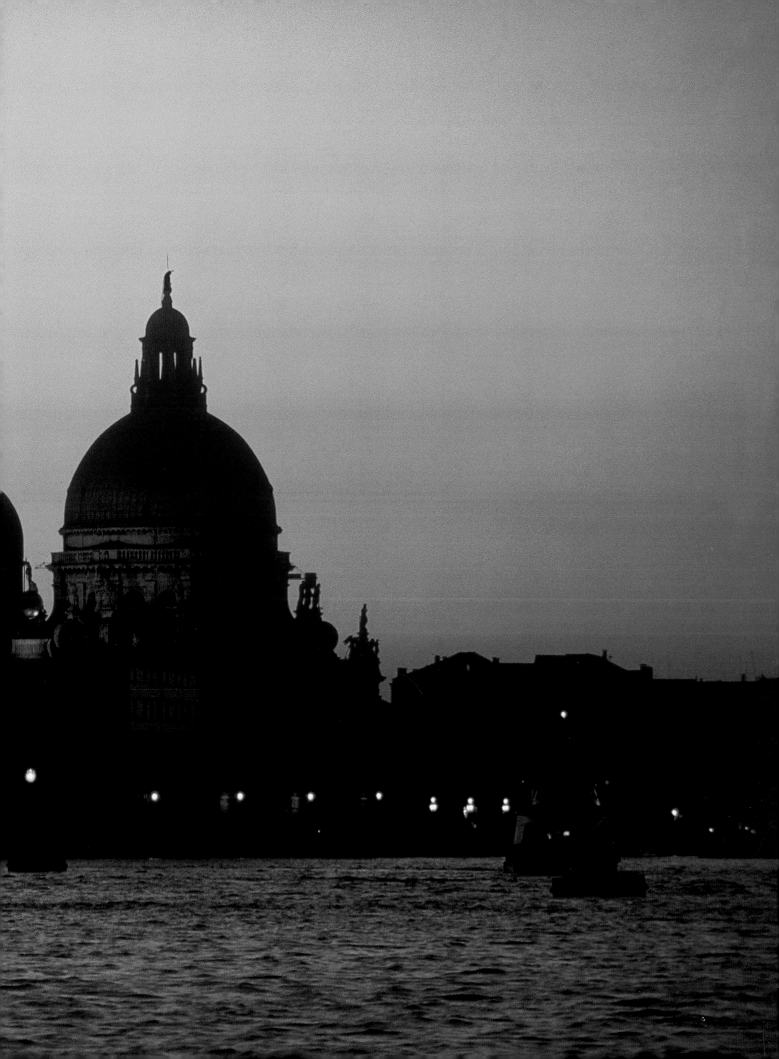

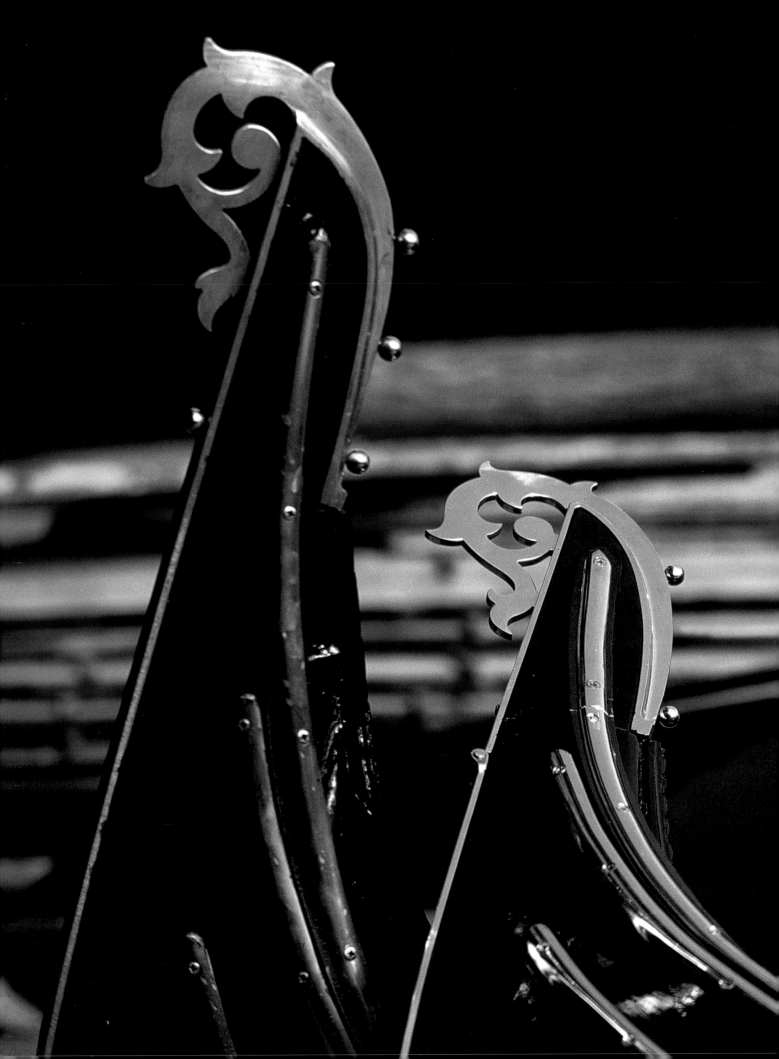

VENICE

CITY OF ART

Text
Matteo Varia

Photographs
Livio Bourbon

Translation
Richard Pierce

Editing and layout
Fabio Bourbon

Pages 2-3 The façade of the Doge's Palace viewed from St Mark's Basin.

4-5 As evening approaches, Santa Maria della Salute stands out against the enchanting spectacle of the golden and reddish hues of the sky.

6 The iron prows of the gondolas, which are still hand-made, shine brightly in this squero or boat yard founded in 1884 by Domenico Tramontin.

7 The patron saint of Venice stands high over the loggia of St Mark's Basilica and protects the lagoon.

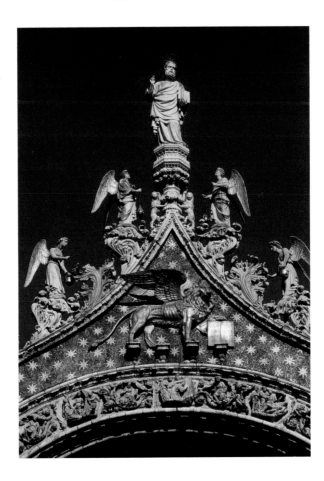

Published in 2006
by I.B.Tauris & Co Ltd

6 Salem Road
London W2 4BU
175 Fifth Avenue
New York NY 10010
www.ibtauris.com

In the United States of America and Canada distributed by Palgrave Macmillan a division of St. Martin's Press
175 Fifth Avenue,
New York NY 10010

First published in 2005 by Priuli & Verlucca, editori
Copyright © 2005
Priuli & Verlucca, editori / Italy

ISBN 1 84511 200 8
EAN 978 1 84511 200 4

A full CIP record for this book is available from the British Library.
A full CIP record is available from the Library of Congress.
Library of Congress Catalog Card Number: available

Printed and bound in Italy by Mariogros / Turin

VENICE

The Venice Lagoon was formed around the first millennium BC when strong, high breakers made several ruptures in a massive series of dunes. The wind did the rest, and vegetation soon colonized the remaining sand. Thus, for almost 3000 years, a long sandbar has protected a vast swamp area, the capricious creation of several river mouths, from the sea: the Piave, Brenta and Sile flow into the basin but have no access to the Adriatic.

Consisting of water and sand, the basin belongs to neither land nor sea. With the help of the fury of the elements, the swamp has become a boundary, so to speak, that both unites and divides two worlds. At first glance this new environment does not appear to be all that unusual: tongues of land project into the brackish water, the light shines brightly on the surface of the wind-rippled water, and the sediment sinks to the bottom. But everything is moving, albeit slowly. The ebb and flow of the tides through the waters' narrow passages is reminiscent of the waves breaking on shores beyond the sandbars. Fresh water from the rivers and saltwater from the sea merge to create a murky mixture that flows out of and then back into the lagoon.

The basin hosts an ancient, mysterious ritual over which the moon officiates. A natural magic defends its delicate ecosystem by removing sand and mud from the bottom and thus slowing down the course of its destiny. The vast and placid water is also the home of islands that attract earthquakes and floods. Islets with indefinite contours that barely rise above the line of the horizon are reflected in the water and seem to melt away at the point where the sea touches the sky. Along the inner edges of the lagoon, stretches of shallow water hosting luxuriant vegetation are submerged only when the moon lies in conjunction with or in opposition to the sun. Here and there the flow of the tide marks the slightly elevated borders of these concave shoals.

The lagoon, like the evolving water creature it is, will disappear, become amphibious, and then turn into a land creature. The waterways that flow into it inexorably deposit coarse sediment, thereby narrowing its passages. Those wells that remain in the innermost zones that the tides cannot reach are inevitably filled with sand. The sea, on the other hand, tends to extend its dominion. Pushed by the wind, it compresses the helpless, unsteady islands in a continuous attack, with no holds barred: under such a violent onslaught, the sandy shores often give way and break up.

It was in this changeable and desolate environment that, spontaneously and slowly, the city of Venice grew on these sandy – and in the fifth century still rather barren – islets where only a few fishermen and salt workers had lived since time immemorial. We can imagine these people over the centuries slowly moulding the elements, creating a city of sand and wood, water and stone. The living conditions of the lagoon's inhabitants must have seemed strange even to their

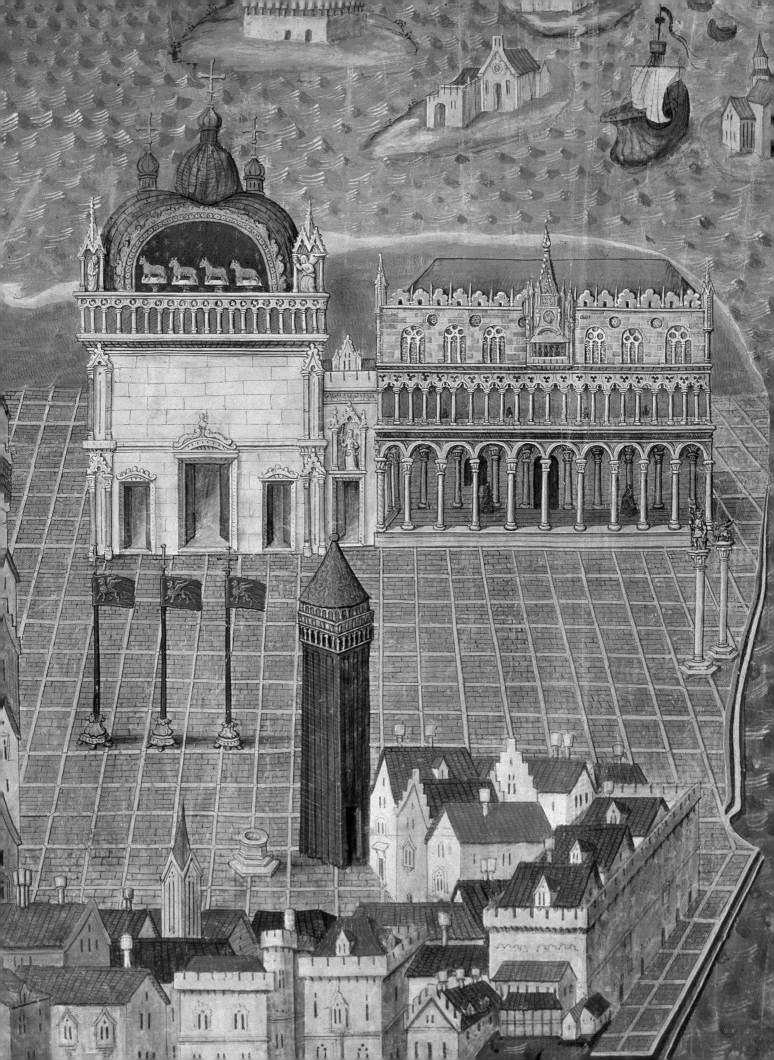

peers. In fact, in the sixth century Cassiodorus, when speaking to fugitives from Aquileia who had found refuge in the Venice Lagoon, exclaimed: *"Hic vobis aquatilum avium more domus est"* (Here they live like aquatic birds).

To grasp the character of the city of Venice and of its civilization, one needs to be acutely aware of its deep-rooted association with the lagoon. The key to interpreting this relationship lies in the history of the city's men and women, in how they exploited the resources of their environment and how they faced the dangers these presented. Wresting the origins of Venice from the blurred image of the wild, violent Dark Ages is a difficult task, for the city's history has provided many theories but few documents that contain concrete data. Between the fifth and seventh centuries the Venetii allegedly had to abandon their lands and take

shelter in the lagoon to escape the massacres and pillaging that inevitably accompany war. According to legend, Venice is the child of a helpless population assailed by barbarian peoples. The invasion by the Huns was soon followed by that of the Lombards and, in the newly conquered land, the Lombard king

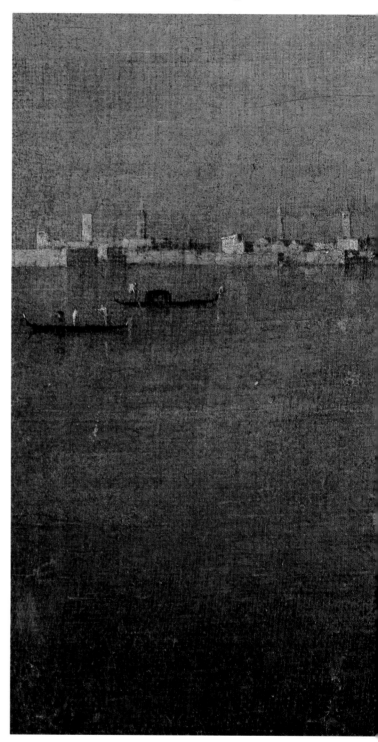

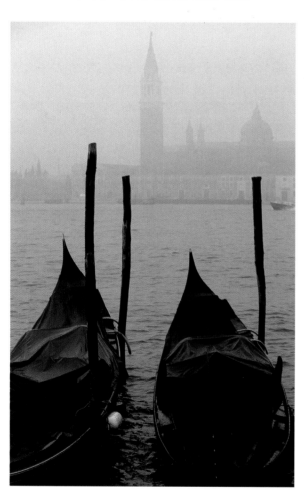

9 During the heyday
of humanism an
anonymous 15th-
century illuminator
painted this view
of St Mark's Square
(Musée Condé,
Chantilly).

10 On the lagoon
everything is enveloped
in fog, and the
evanescent profile of
S. Pietro Maggiore
gives the impression
that time and space
are suspended.

10-11 In the past as
in the present, the mist
lends a vague sense
of apprehension to the
city (Francesco Guardi,
Gondola on the
Lagoon, 1790, Museo
Poldi Pezzoli, Milan).

Liutprand must have been no less cruel than the infamous Attila.

The Venetii who fled from the barbarian massacres found a haven on the islands in the Venice Lagoon, for their geography guaranteed a rather peaceful existence. However, they kept in contact with their kinsfolk, or at least continued the various activities that were common on the mainland. We can surmise that the upper

12-13 In the Venice Lagoon the golden sun shines on the surface of the barely rippled water. Seemingly without weight or volume, San Giorgio Maggiore church is unveiling its beautiful Palladian features.

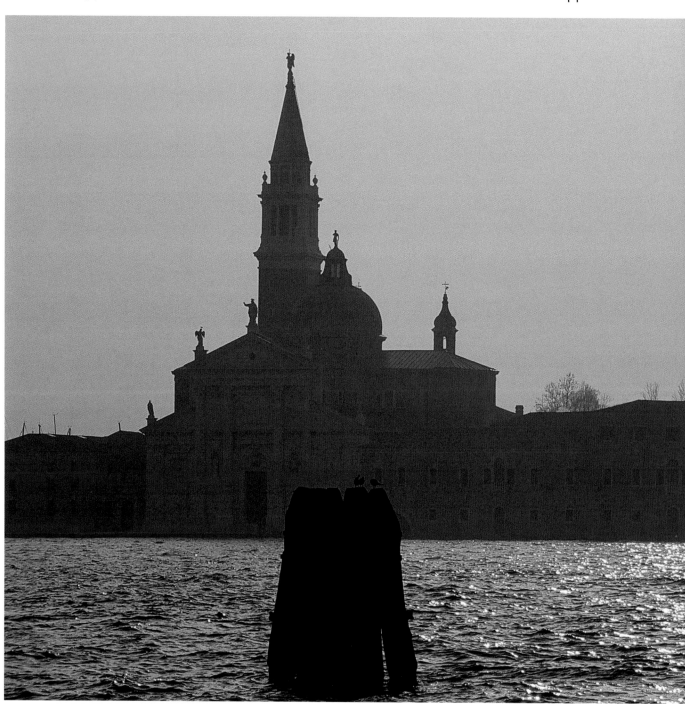

classes gradually transferred their economic activities to the lagoon. First they set about reclaiming the islands and then, profiting from the development of trade triggered by the safe harbours, they settled there.

Arriving in these islands was fraught with danger, for it was easy to run aground on the shoals and there were no means of access for large ships. In any case, the Lombards disliked the sea so much that they considered the shallow waters of the lagoon as impenetrable as very high walls.

In this natural fortress the Venetians struggled hard to attain political independence, a status that did not rule out diplomatic relations with the Byzantines and Lombards. All the same, the Venetians had a strong bond with the former, for the Lombards must have seemed coarse and ignorant to them given that they were unable to conform to the etiquette required in official ceremonies and wholly lacked the grace and good manners that the aristocracy of Rome and Ravenna so appreciated.

Venice could not help but be influenced and inspired by the distant Byzantine Empire; for that matter, the presence of nobles, merchants and carpenters from Byzantium must have been strongly evident. In fact, as early as the tenth century, the emperor of the eastern Roman Empire, Constantine VII Porphyrogenitus, described the many emporia and castles that populated the islands of the Venetian coastline. The influence of Byzantium on the lagoon civilization was evident from the widely-practised customs of Venetian noblewomen. A scandalized Pier Damiani described the habits of Duke Domenico Silvo's wife (perhaps the Byzantine princess Theodora Ducas): she washed herself only with the "dew from the sky", ate with a small fork and scented her bedroom with all kinds of incense and perfume. The holy monk was certain that God would punish her with a disease worse than leprosy.

The city's pro-Byzantium policy soon proved to be advantageous: when Charlemagne's son Pippin sought to extend Frankish dominion to the Venetian lagoon he was blocked by an intervention from Constantinople. It must be said that an invasion by the Franks would have profoundly changed the character and future of Venice. In 809 Pippin managed to

form a powerful fleet of stolen ships. We can imagine Charlemagne encouraging his son to show those islanders the full might of the Holy Roman Empire and to use any means to punish them for their arrogance. In the meantime, the Venetian Consiglio or Council met at the Rivoalto and decided to wait for Pippin's fleet in the lagoon. Attracted by small boats into what is still known as the Canale dell'Orfano, the Frankish fleet ran aground because of the low tide and was totally destroyed. In that same period another large settlement grew up on the island of Olivolo, which, along with Rivoalto, constituted the first residential and council centres of Venexia. Rialto Bridge, now a popular tourist attraction but once the centre of trade and commerce, is the best-known site to retain

the ancient name of the city (Rivoalto, the contraction of which is Rialto).

Venice, with its six present-day *sesitieri* or districts – San Polo, Santa Croce, Cannaregio, Castello, San Marco and Dorsoduro – surrounds the Rialto. Not far away in the lagoon are the island of Giudecca and the Lido. The ancient Rivoalto community has left traces of the unique civilization it generated. In his *Travels to Italy*, Goethe writes: "Parsimonious about every inch of land, from the outset packed into narrow spaces [...] the Venetians used the water as their streets, squares and promenades. The Venetians had to become a new species of human being, just as Venice can be compared only with herself. The Grand Canal, with its winding turns, is second to

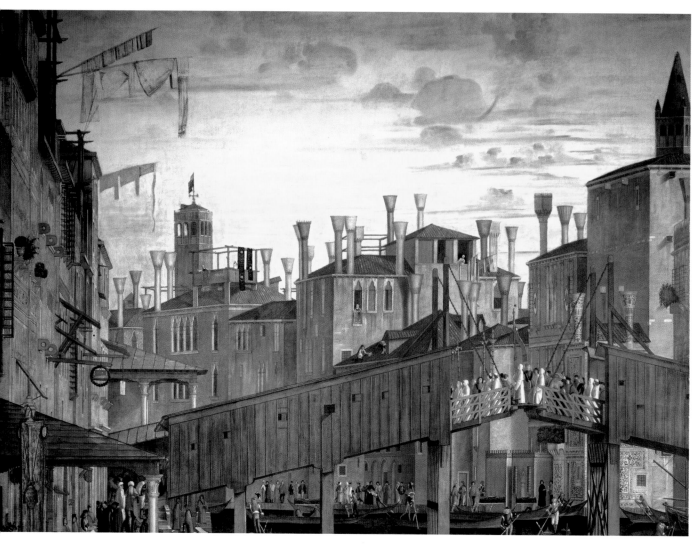

no other street in the world as regards beauty, nor is there any area that bears comparison with that in front of St Mark's, by which I mean the great expanse of water that is almost embraced in a crescent shape by the city itself."

The characteristics of the burgeoning Venetian state now began to emerge rather clearly. The doge, whom the *major pars* or majority of the people (*placitum*) elected directly with the help of two tribunes, wielded the power. The new duchy, or Dogado, the headquarters of which were moved from the island of Malamocco to the Rivoalto in 810, soon became the leading commercial hub of the widely dispersed Byzantine world, the Latin-Germanic Carolingian Empire and the coastal Slavic world of the Balkans. For centuries the Venetian Lagoon remained the same, as if in a deep slumber disturbed now and again by internecine struggles and wars of conquest. This situation lasted until the end of the Low Middle Ages when, perhaps buoyed by the frenetic fashion throughout Europe to build defensive walls around old towns and cities, something began to change in Venice as well. The urban landscape appeared to have reached a stage of transition; more and more wooden houses were being built, which soon covered the entire surface area of the islands, and the city took on its irregular profiles. Though stone houses were by no means rare, they were mainly inhabited by foreigners, while the doges and judges, in their privileged positions, lived in splendid *palazzi*. The construction of numerous parish churches, monasteries and cathedrals reflected the people's confidence and pride in their new, flourishing city life.

Myths started to circulate about Venice, stories of fantastic events that touched so closely on the tangible sentiments of the community that they were believed and were handed down from generation to generation. According to a twelfth-century

chronicle, many centuries earlier a fire had broken out in the house of a Greek called Architon, a *magister navium* or ship commander, on the island of Rivoalto. The flames spread among the wooden buildings and, with 24 houses already alight, the entire district was seriously threatened. Aristocrats and commoners alike knelt around the leading magistrate and vowed to erect a church (San Giacomo di Rialto) in honour of the blessed James the Greater on the site where the fire had broken out if he would help them. Suddenly a strong wind began to blow and heavy rainfall extinguished the fire. Nowadays, the influence of centuries of scientific tradition on our way of thinking might lead many to doubt that the blessed soul of James, which was waiting to be

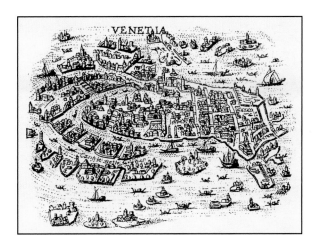

14 In this detail of Vittore Carpaccio's famous Healing of the Possessed Man at the Rialto (1494), note how in the late 15th century the Rialto Bridge was still made of wood, like the first medieval bridge that is traditionally ascribed to Nicolò Barattieri (Galleria dell'Accademia, Venice).

15 The work of an anonymous early 17th-century cartographer, this bird's-eye view of Venice is particularly interesting. Note, among other things, how the engraver has represented the lagoon overflowing with boats (detail of a map of Italy, c. 1600, Private Collection).

sanctified, had actually triggered the downpour. However, quite apart from the fantastic and religious elements, myths were an authentic feature of everyday life in the early Middle Ages. Once the Roman Empire had fallen, the Church was the only potentially universal institution in western Europe and it became the true heir of late imperial culture. The ecclesiastical institutions maintained not only the hierarchical power structure but also most of late Roman juridical culture, and even the custom of having short hair. The Christian faith – and the church as its concrete architectural expression – united the heterogeneous population of the Venetian lagoon under a single roof. Fires must have been a grave danger for a city consisting mostly of wooden structures. In fact, fire seriously damaged St Mark's Basilica in 937 and again partly destroyed it only 130 years later.

Towards the end of the early Middle Ages the lagoon, the ancient asylum for refugees fleeing from the violence of invaders and the sackings of their cities, could no longer be considered a mere place or safe refuge. With the development of settlements, and the high level of organization and exploitation in the territory, it now had to be considered a proper urban space, a city. We can now speak of Venice as a true city, although its Latin name Venetiae suggests the persistence, and not always peaceful coexistence, of different independent centres of power. However, with the gradual dissolution of the Byzantine Empire, which Charlemagne's death and the rapid collapse of his realm no doubt accelerated, Venice emerged as the undisputed queen of the Adriatic Sea. With such power invariably flaming the ambitions, plots, conspiracies and struggles of warring factions, we often find the Venetians engaged in cruel conflicts. The opposing factions inevitably mirrored the schism that existed between the east and west of the Roman Empire and that now split the ancient world in

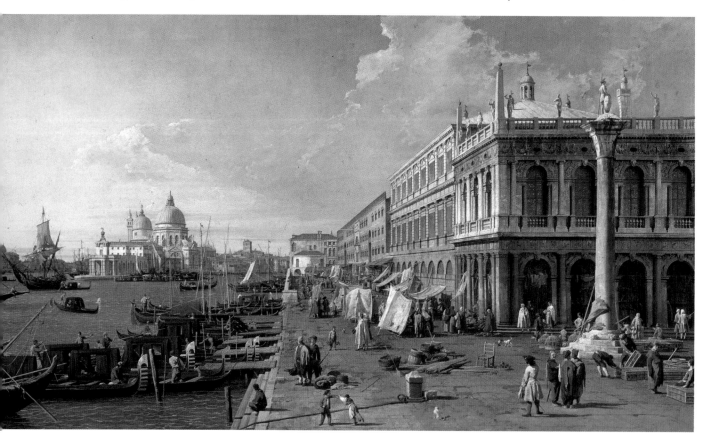

two. The characteristics of each side are perhaps best expressed in how they punished those who engaged in conspiracy – in Byzantium they were blinded, while in the Frankish world they were confined in a cloister after the removal of their beard and hair.

The internecine struggles did not, however, hamper the rise of the Serenissima, or Most Serene Republic. It was so glorious that Pope Gregory VII, ever mindful of a chance to seek their favour and support, stated that the citizens of the lagoon had the same spirit that had made Rome so great and that Venice was its most direct and logical heir. The famous Marriage to the Sea ceremony bears witness to the central role that Venice played in European politics. The twelfth century saw the outbreak of war between the Empire and the city-republics, which were loath to recognize the demands of an arrogant monarch from a faraway castle in another land. Pope Alexander III, recognizing the perfect

Three other views of Venice, this time in the first half of the 18th century, one of its periods of maximum splendor.

16 Canaletto, The Molo with the Library and the Column of St Theodore (c. 1735, Private Collection, Rome).

17 above Canaletto, The Grand Canal from Campo San Vio (1730-35, Pinacoteca di Brera, Milan).

17 below Canaletto, The Imperial Ambassador Count Bolagno Being Received at the Doges' Palace (1729, Aldo Crespi Collection, Milan).

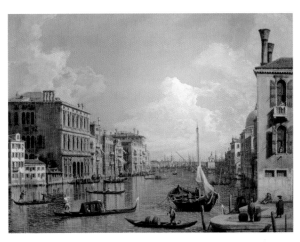

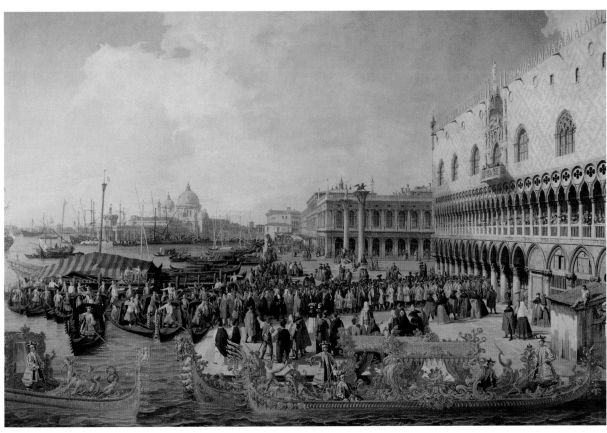

18-19 The Bucintoro was a luxurious ceremonial ship decked with fretwork and entirely encrusted with gold leaf that was used on Ascension Day to celebrate the marriage of Venice with the sea. Here the ceremony is represented in Francesco Guardi's The Doge on the Bucintoro at Sant'Elena (1766-70, Louvre, Paris).

opportunity to remind the emperor who really had the rightful claim to universal power, sided with the city-republics. Emperor Frederick Barbarossa's response was to appoint an antipope, who proceeded first to excommunicate Alexander and then to pursue him with a view to putting him in prison. Alexander III sought refuge in Venice and the republic soon offered to mediate between the two powers. Frederick agreed to travel to Venice to meet the pope. At Chioggia he received three cardinals, who brought him

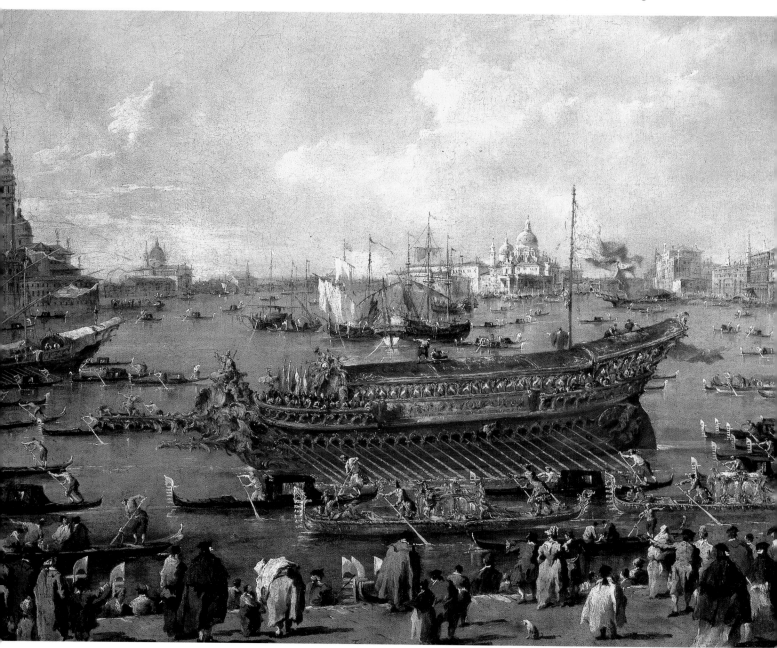

the pope's pardon. Then, in the San Nicolo monastery in Venice, the emperor prostrated himself before Pope Alexander, who descended from his throne and embraced him. Well aware of the major contribution they had made towards this peacemaking, the Venetians skilfully obtained from the pope his investiture as masters of the Adriatic. This high recognition was added to the title of Dux Dalmatie (Lord of Dalmatia), which the Byzantine emperor had already conferred on Doge Pietro Orseolo for having

defended the Dalmatian islands from Croatian and Narentine pirates. As a token of the investiture, Pope Alexander gave the doge a ring with the following words carved on it: "Accept this as a token of the perpetual sovereignty that you and your successors will have over the sea."

This ring that the pope donated was the very same one that is used to bind the doge and Venice with the sea in the Marriage to the Sea ceremony. On the day of the Sensa – that is of Christ's ascension to heaven – the doge goes to the mouth of the port of San Nicolo di Lido and, with the stern of his ship facing the open sea, throws the ring into the water. After being blessed by the bishop, the ring is cast in the same place where the bishop had previously poured a large vase of holy water. While the ring is sinking, the doge utters the following phrase: *Desposamus te, mare, in signum veri perpetuique dominii* (We wed thee, oh sea, as a sign of true and perpetual dominion). We do not know what happens to the ring, but perhaps some shipyard worker dives into the water to retrieve it. The day of the Marriage to the Sea is inaugurated with a large fair that lasts for several days; for this occasion a grandiose arcade is built to protect the merchants, artisans, artists and spectators from bad weather. On offer at the fair are all the goods produced by Venetian industries or sold by local merchants, which is tantamount to saying that there is more on offer than anyone could normally desire. For example, as a young sculptor Antonio Canova exhibited his Daedalus and Icarus at this fair. In 1776 the Venetian Senate commissioned a new grandiose arcade and these festivities achieved unheard-of splendour. However, for centuries the power of Venice had been waning and had become a mere reflection of itself, an image fossilized on the changing surface of the lagoon's waters. The poet Angelo Maria Labia ends his celebrative sonnet in Venetian dialect about the splendour of the Sensa with a

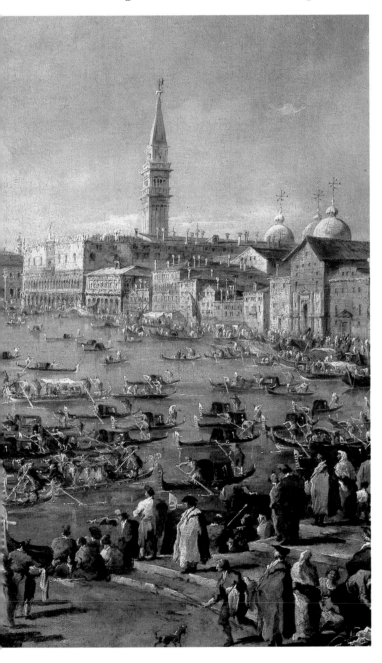

verse that expresses the premonition of the city's end among the sensitive souls in Venice: *"Epur, no so el parché mi pianzaria"* (Yet, I don't know why, I feel like weeping).

There is no reason to believe that the Marriage to the Sea ceremony included the use of the *Bucintoro* from the outset. This luxurious ceremonial ship, 100 feet long and 21 feet wide, was on two levels: the lower one would be for the oarsmen, the *arsenalotti*, members of the glorious militia of the Arsenal, while the upper one was covered with a crimson velvet *baldachin* dedicated to the doge, who would sit at the stern with the Signoria (the highest Council of Venice) and his guests. The entire ship was covered in gold. Unfortunately, even this marvellous product of refined Venetian art has not been preserved. Having conquered Venice, Napoleon's troops, the offspring of the French Revolution, did not forget to follow their time-honoured tradition of sacking the city. These 'liberators' had no

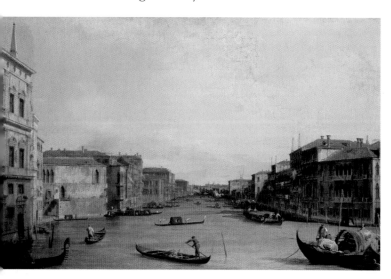

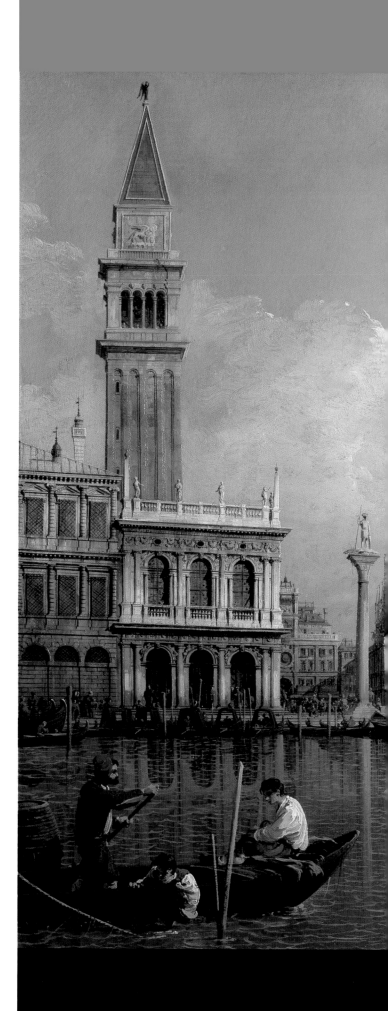

Before the drastic changes wrought by the Austrian governors, Venice had no true street network to speak of and city life virtually took place in the canals.

20 Canaletto, The Grand Canal Seen from Palazzo Balbi *(c. 1726, Uffizi, Florence).*

20-21 Canaletto, St Mark's Basin *(c. 1735, Pinacoteca di Brera, Milan).*

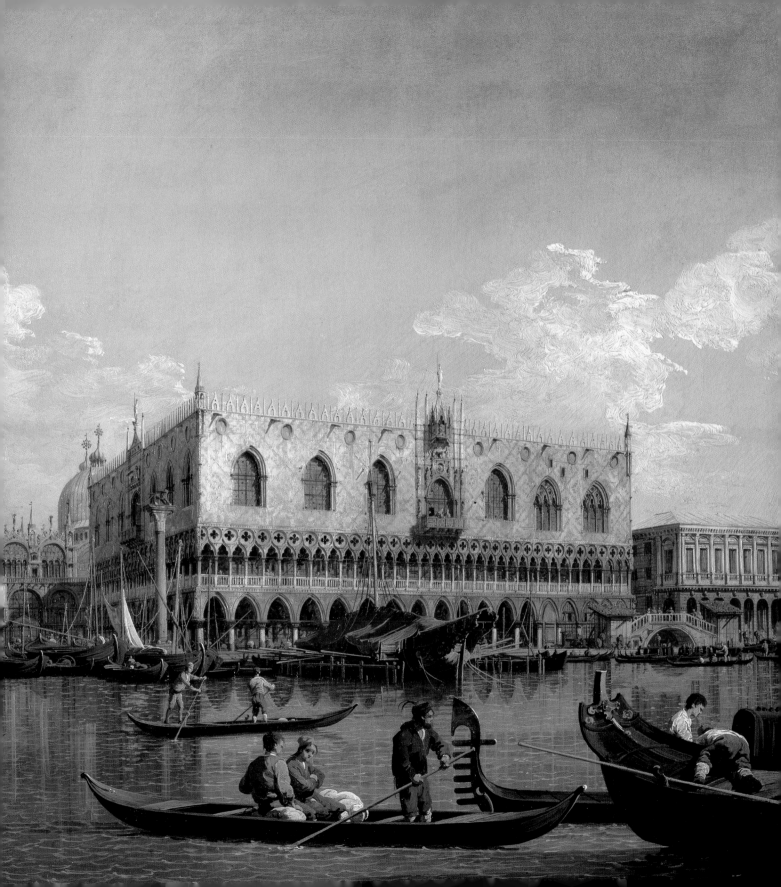

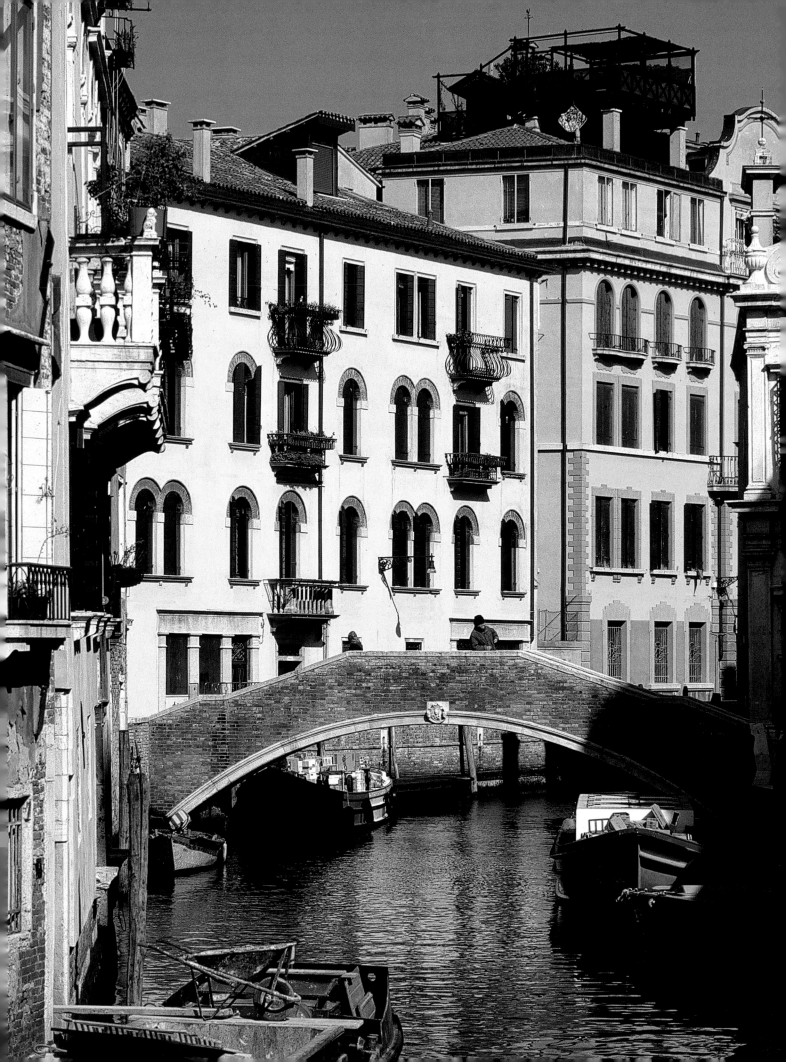

qualms about burning the *Bucintoro* to melt down its gold and steal it in one fell swoop – thereby providing an original interpretation of the highly rational ideals of the Enlightenment. The institution of the Marriage to the Sea, which the Venetian Senate sanctions, signifies both a full awareness of the Venetians' power and the political justification for their dominion over the sea.

At this stage, since it is impossible to narrate in a few pages the more than five centuries in which the world, and Venice along with it, were transformed, we will leave to others, who are more competent and better informed, the task of relating the many events that constituted the history of the Venetian Republic, leading to the period of greatest splendour and expansion and, ineluctably, to its demise. We need only say that over the centuries the changes made in the lagoon area became more and more rational and planned, and the technical know-how of Venetian engineers was used to safeguard the subtle equilibrium of the Republic's territory. From the fifteenth century onwards, thanks to grandiose canalization works, the rivers flowing into the lagoon were systematically diverted. To defend Venice from the sea, the citizens imitated Nature and built new, more resistant shoals in strategic places – the so-called *murazzi* or sea walls, which protect the Venetians to this day.

The identity of present-day Venice began to take shape in the first half of the nineteenth century. This was when, in the space of only a few decades, the city's primary political and economic role collapsed. This decadence is a fundamental aspect of the Romantics' vision of Venice as a 'city-monument' or 'city-museum' unable to find new stimuli. Thus, an unpleasantly stereotyped image of the city was created that is frequently superimposed on the real one, which is infinitely richer, more complex and alive. Napoleonic and then Austrian dominion

Water, wood, stones, bricks and a rich array of color constitute the fragile body of Venice and represent a city with a two-fold nature in which canals, narrow streets, bridges, and fondamenta interweave and face one another.

22 A lovely stone and brick bridge over the Rio della Pietà canal.

23 Two views of the Dorsoduro district.

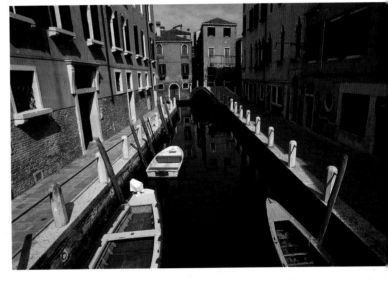

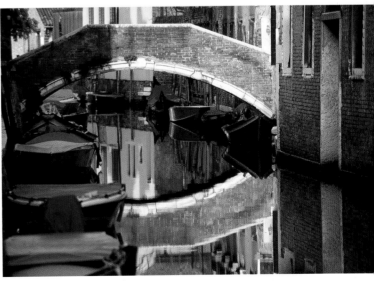

While walking through the city, visitors may discover that the labyrinth of calli and canals has suddenly disappeared.

24 The narrow rughe (streets with houses and shops) converge at a spacious square in the Castello district.

24-25 In the beautiful palazzi at Dorsoduro the shutters are opened to take in the warm light of day.

25 The impressive bell tower of San Giorgio dei Greci Church soars over the bright Rio dei Greci.

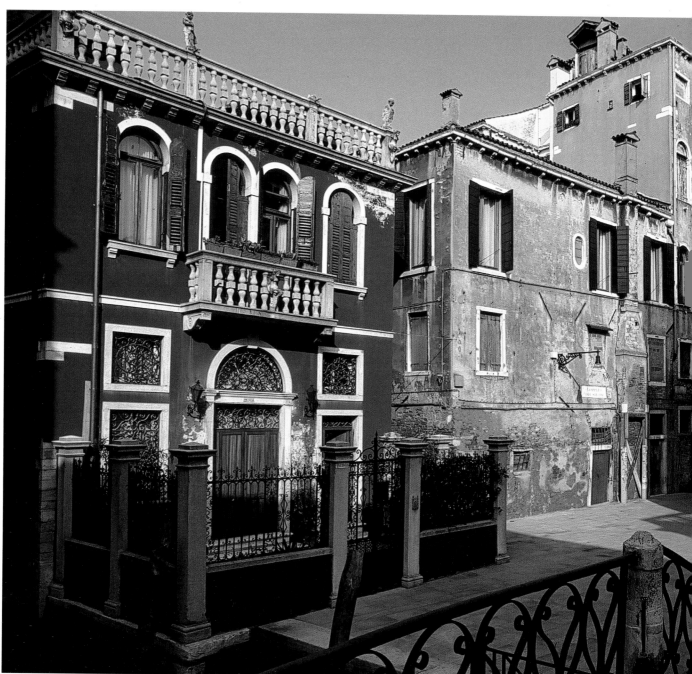

24

led to a drastic change in the city's relations with European nations and empires. The new governments were incapable of understanding the needs and peculiarities of the city. Venice, a precious jewel, became part of a territorial kingdom and, as such, was governed impersonally and bureaucratically. The railway bridge, built in 1841–46, along with a network of pedestrian passages that flank or replace the canal system, which was considered anachronistic, were part of this gloomy metamorphosis. These changes, which were drastic and involved the total renovation of the urban fabric, were based on the eagerness for innovation of a forward-looking society that believed it was heading towards a future that would be glorious, civil and above all technological. Up until that time the canal network had been the backbone of the city, while the pedestrian passageways had

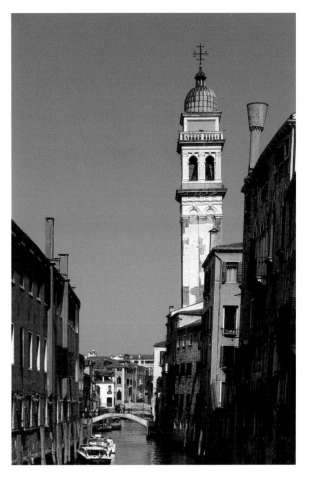

functioned only as a secondary traffic system, which is why they had never been developed very much in the first place and had never had a precise part to play in the town planning of Venice. The need to connect the railway station with the nerve centres of the city led to the planning of new pedestrian thoroughfares that were to be constructed at the price of demolishing historic buildings and filling in canals.

The long S. Lucia railway station–Lista di

The canals and streets often flank one another or pass under or over one another.

26 above A common sight is an alleyway running parallel to a canal, or a canal, bridge and fondamenta heading in the same direction. Here we are in the Dorsoduro district, but this

singular sight can be seen everywhere in Venice.

26 below Another view of Dorsoduro, with another characteristic Venetian bridge.

27 A stairway descends to the boats in the Orseolo basin, near St Mark's Square.

Spagna–Strada Nuova–Rialto pavement, which was laid out north of the Grand Canal and which unfortunately disrupted and destroyed a large section of the district south of Cannaregio, was among the most drastic of these projects. Other changes were less ruinous; for example, the railway station–Rialto–St Mark's Square plan only entailed building the Scalzi Bridge. But, on the whole, the town planning renovation of the city greatly changed its character and some of its identity was lost forever. We all know very well that old Venice had thrived around its network of canals, which branch out perpendicularly from the Grand Canal and the other major canals, which in turn gravitate around St Mark's Basin, St Mark's Square and the commercial area of the Rialto. The zones farthest from the centre of town and the shores of the islands were used for specific activities such as the storage and repair of civil craft. However, there were no suburban zones, but rather many small specialized centres around which the various activities pertaining to community life were organized. With the new town planning projects Venice became a city that could be passed through on foot in the least possible time. Yet you can still see some signs of its former appearance if you follow itineraries off the beaten path, where you may get lost is a maze of alleys that rarely go in one direction only.

Although Austrian dominion deprived Venice of its freedom, it could not make it lose its fascination. The image of Venice in chains, as the slave of a foreign power, troubled and inspired generations of writers and poets. The echo of its melancholy melody resounds in D'Annunzio's *Fuoco* (Fire) and in Thomas Mann's disturbing tale, *Death in Venice*. The image left by medieval literature, as brilliant and limpid as an inlay of precious stones, dissolves. Georges Lengerand, the Belgian ambassador to Venice in the fifteenth century, still presents us with a

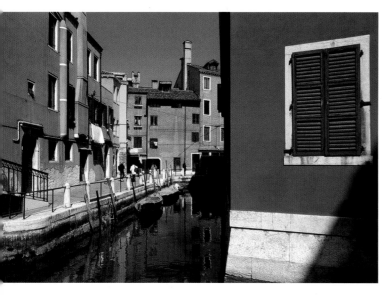

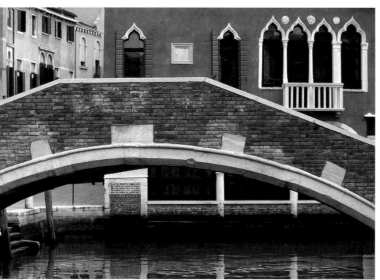

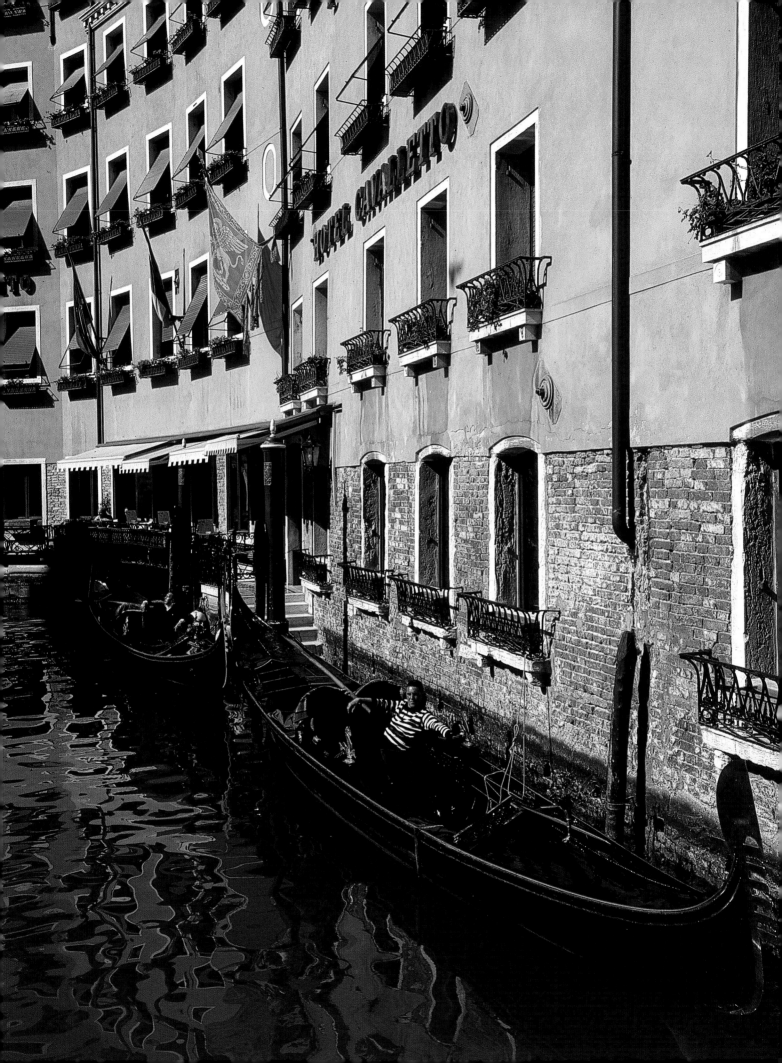

lively picture of puerile admiration: Paris, Bruges and Ghent cannot be compared with the splendour of Venice, with its luxurious *palazzi*, its rich merchandise, the industriousness of its shops and the bold elegance of Venetian noblewomen who expose themselves "from the top of their head to below their breasts." In 1802 another Venice appeared to Johann Seume: "The palace of the Republic now seems to be in a state of total neglect and the Rialto is occupied by cannons. The soldiers and the inhabitants themselves are to be seen only in St Mark's Square, at the port, at the Rialto and the Arsenal. The

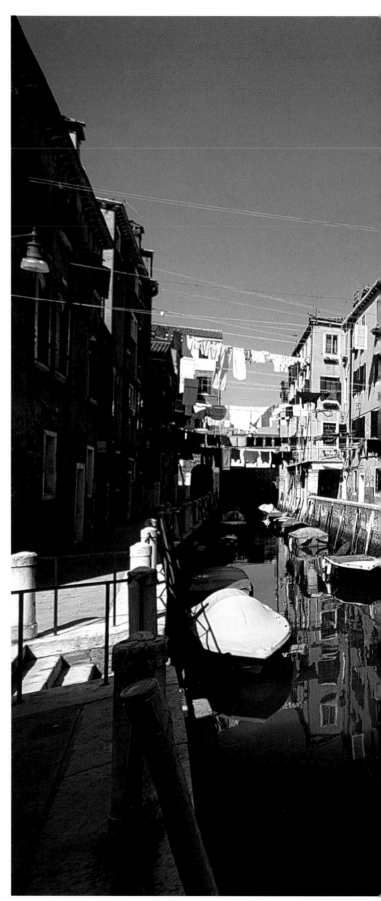

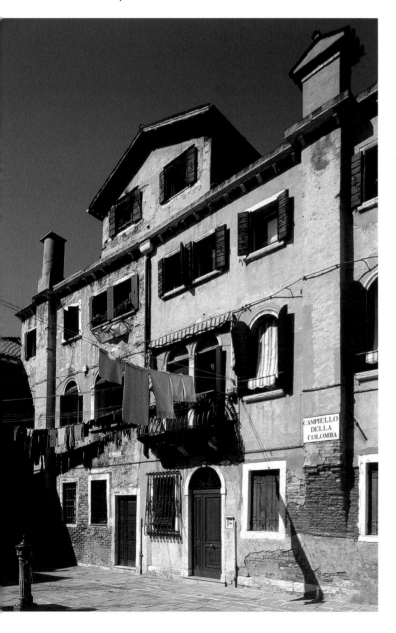

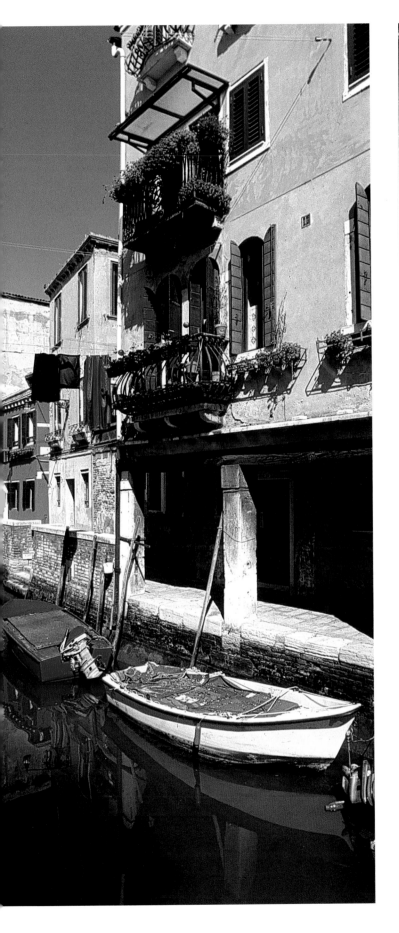

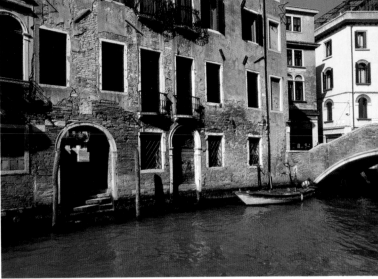

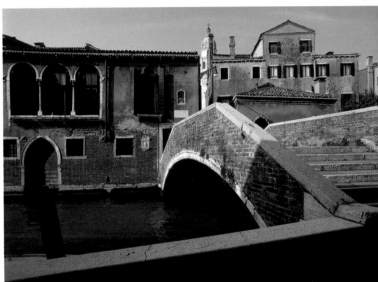

In an "amphibious" city such as Venice, the doors of the buildings may very well open out onto a square or alley, as well as onto a canal.

28 A picturesque building in Campiello della Colomba.

28-29 These buildings along the fondamenta of the Castello district are mirrored in the small canal.

29 above In the Dorsoduro district the door of a lovely small building looks directly onto the canal.

29 below Another door overlooking the water, a sight that is only apparently strange.

30-31 Suspended over the water, Venice is broken up into fragments of reflected images: in certain cases the city itself seems to be the dream of a mad creator. The houses, reproduced as if in a mirror, are mobile and transparent and seem to reveal the ephemeral nature of all human construction.

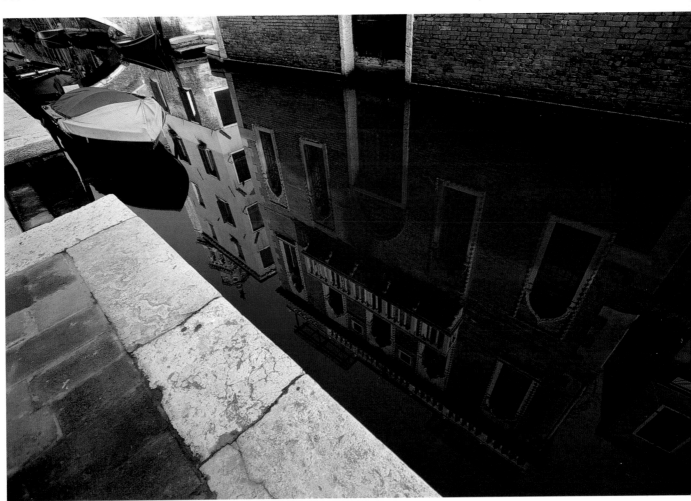

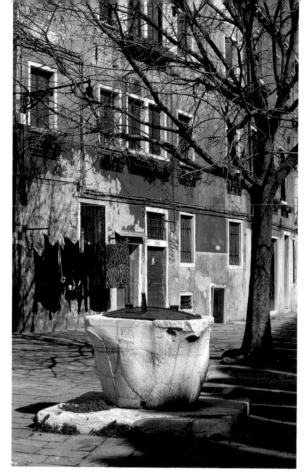

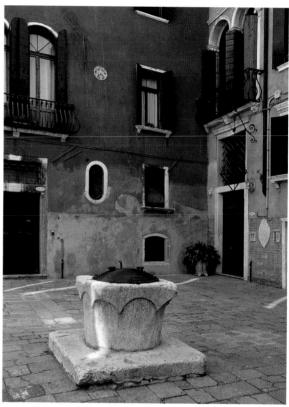

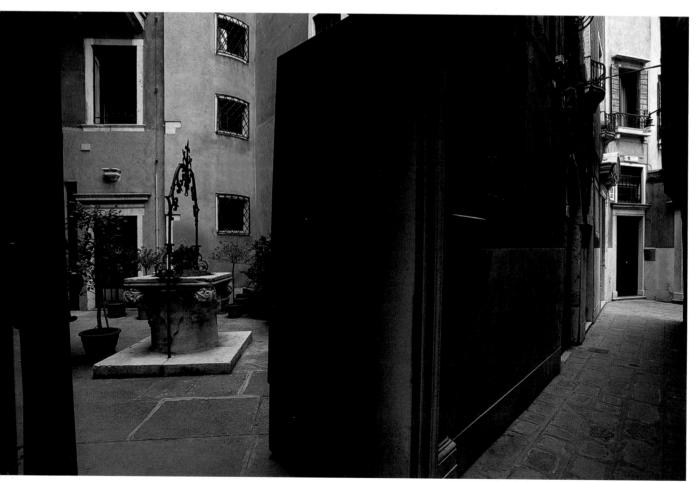

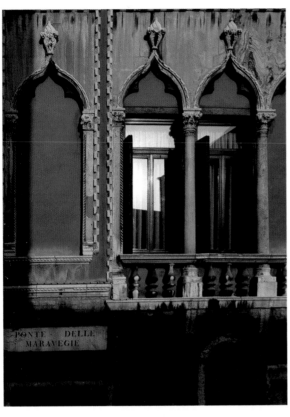

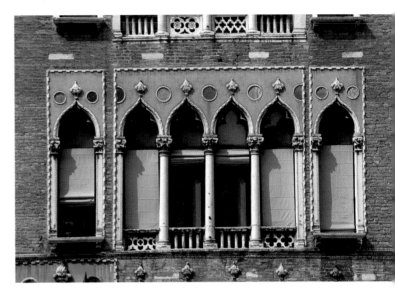

32 The typical wells sculpted from a single block of stone are to be seen in most of the courtyards.

33 The ogee arch windows with their elegant tracery evoke the distant Orient as well as the flamboyant Gothic style of Europe.

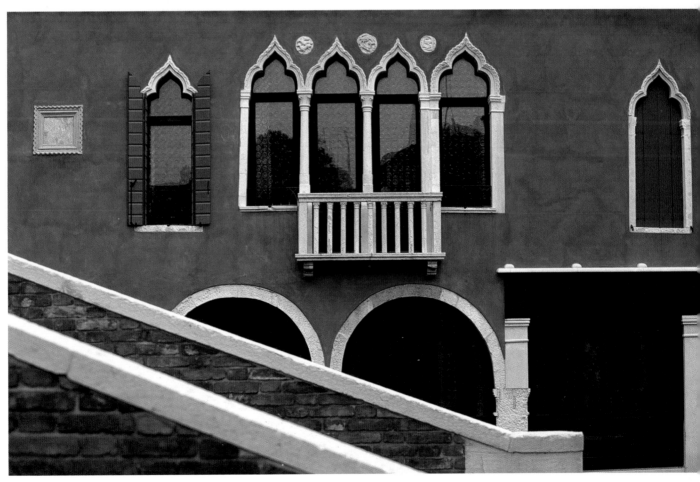

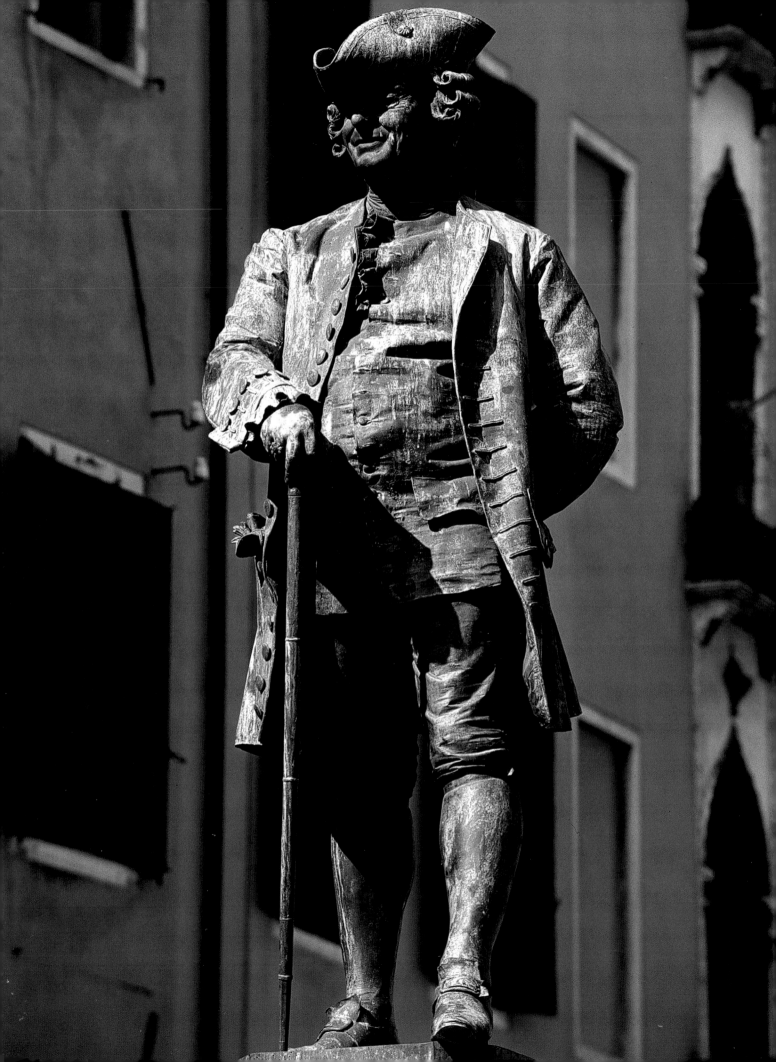

Like all cities, Venice boasts a heterogeneous population of statues tarnished by the ravages of time.

34 Born in Venice in 1707, Carlo Goldoni abandoned a judicial career to devote all his energy to writing plays, imparting new dignity to the comedy genre.

35 left Detail of the gate at the foot of the St Mark's Campanile, decorated with the figures of Minerva and Mercury.

35 right One of the most passionate citizens of Venice was Daniele Manin, a hero who led an insurrection in 1848 against the Austrian rulers.

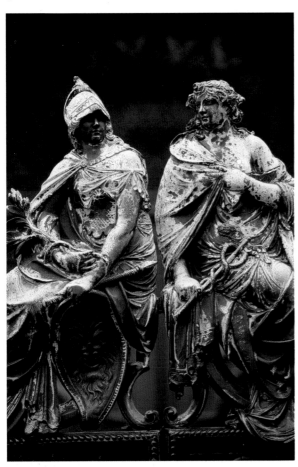

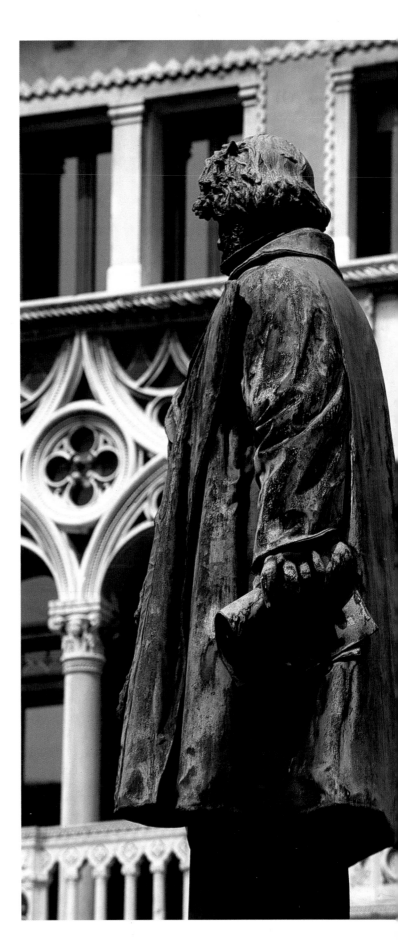

36-37 The gondola is not only a means of transportation, but a veritable emblem. About eleven meters long, narrow and flat, with an elevated prow and stern, it has an unmistakable profile. In this picture, rich multicolored brocades embellish these two magnificent specimens.

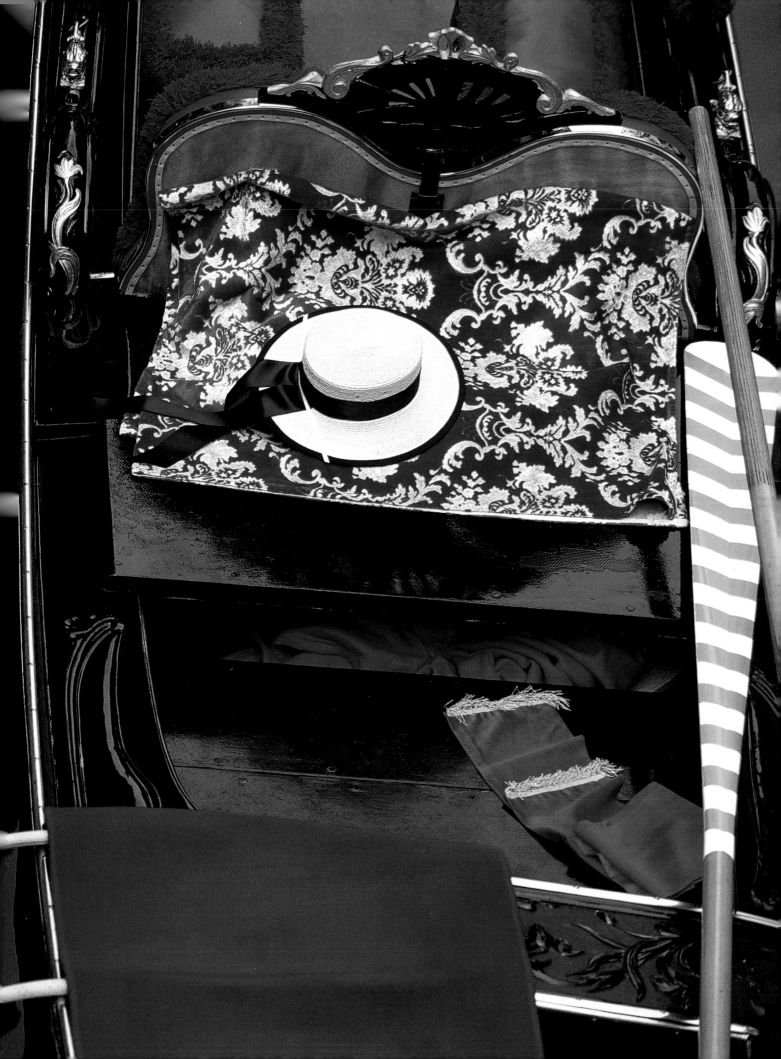

saddest sight in Venice is its poverty and beggars, [...] women of good stock wrapped in thick black veils, kneeling at the steps of churches, holding out wooden bowls." The wounded city became the symbol of ruin, anxiety, ambiguity and life understood as an ineluctable deadly illness – all themes that are picked up by D'Annunzio and Mann and that can we can already recognize in the 1819 description by the Austrian dramatist Franz Grillparzer: "The first impression Venice made on me was strange,

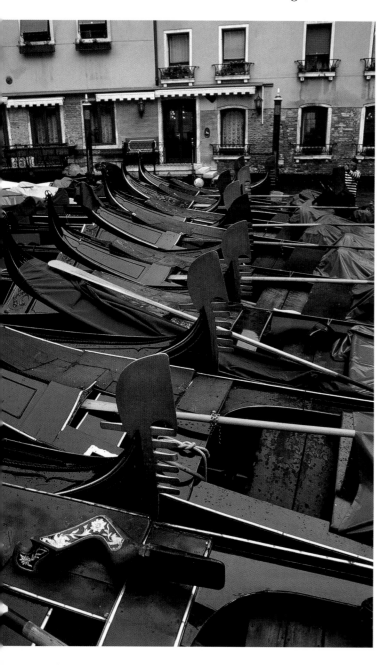

unpleasant because of the limited horizons. These marshy lagoons, these smelly canals, the filth and cries of the brazen, crooked people [...] Rome is dead, but Venice still moves and extends its gigantic limbs to say, against its will, farewell to life." In nineteenth-century literature Venice is perpetually being called upon to enact its death throes. The disturbing image of eternal dying and the vision of its very existence being doomed inevitably lead to an escape to the past or to a tragic future. In the nineteenth century, Camillo Boito – an architect, art critic and novelist who constantly hankered for an original re-elaboration of the medieval aesthetic experience – seduced by the myth of a decadent Venice, was dissatisfied with what he saw and felt the need to create a new, unsentimental image of the city. Boito writes: "When, as at Altino, Jesolo and Torcello, the mire deposited by the rivers will fill in the lagoons and the fevers will cast out the last miserly inhabitants, and the houses all collapse [...] the remains of some age-old buildings will in any case rise up at sunset under the golden clouds. The Frari Church will display its enormous gutted nave [...] The church of SS. Giovanni e Paolo will be a heap of ruins except for the five apses and the statue of Colleoni will remain intact on a shapeless pedestal, but one will have to search for the decoration of the Ospedale opposite, so fine and so delicate, among the rubble and debris. As for St Mark's Square, what an astonishing sight! The mosaics on the inner vaults will be visible in all their golden splendour from outside through the rents in the demolished walls, and the marble, porphyry and alabaster of the broken columns will emanate a strange twinkling effect in that sepulchral sadness."

The character of this passage of Boito's is expressed magnificently in D'Annunzio's adage: "A ruin is more beautiful than beauty itself." D'Annunzio's portrayal of Venice in *Fuoco*, however, with its image

of Foscarina's faded beauty and of the bard's weary, dying love for her, is still fiery, exhilarating, and filled with colour and vivacious figures. But the image of a decadent Venice survives to this day, albeit with postmodern overtones. Francesco Guccini, the famous Italian songwriter and singer, has dedicated a sad lyric to a Venetian friend who died while giving birth. In this song Venice is moribund and wretched; looming gloomily on the horizon is the Marghera industrial complex; the city has become a hotel; St Mark's is nothing more than the name of a restaurant; and the gondola is a futile, superficial toy.

All the various and conflicting images of Venice coexist in disorderly fashion in the common mind. However, the dominating one is that of a superb city of art, a treasure of infinite experiences that must be visited again and again. It is easy to understand how nineteenth-century Venice would appear to be decadent to both the Venetians, who remembered its

38 Venice also has its own curious parking problems.

39 In the Tramontin Squero the long, narrow boats, which are the symbol of the city, are still *handmade, in keeping with the severe rules of tradition. The name of this singular type of shipbuilding yard derived from the word* squera, *the square used by master shipbuilders.*

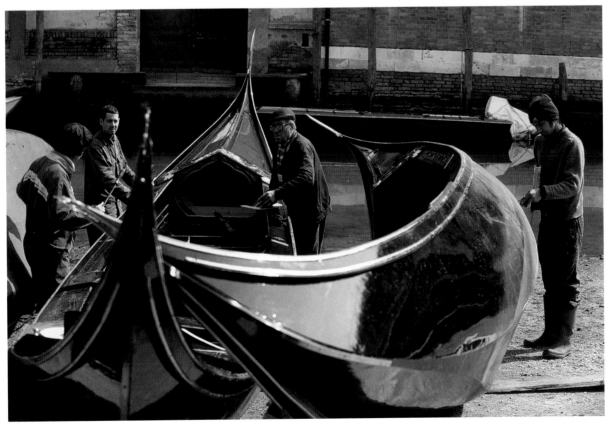

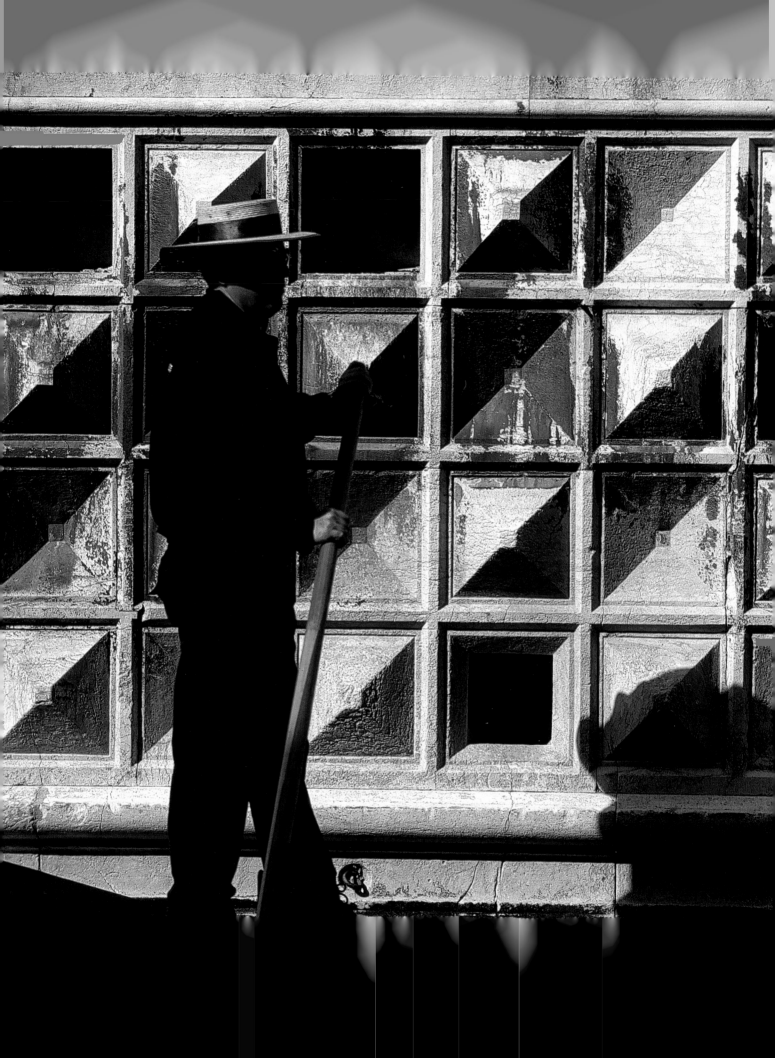

Despite the radical social-economic changes that have occurred, most Venetians continue to spend much of their lives on the water.

40 *The profile of a gondolier against the "checkerboard" wall of the Doge's Palace.*

41 *Two other gondoliers enjoying the sun while waiting for customers.*

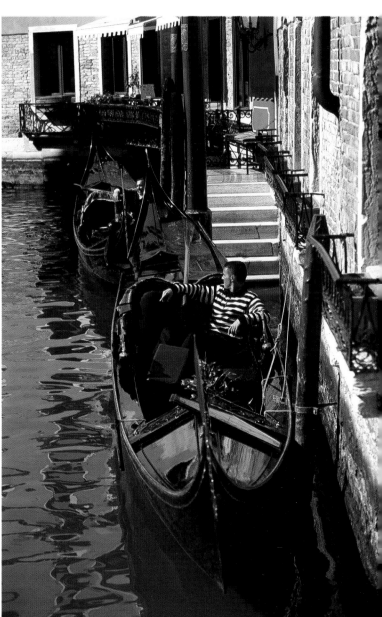

former magnificence, and foreigners, who compared it with the great capitals of European industry and the centres of developing nations. But nowadays, in the context of an ever more complex global economy, cultural treasures are an inestimable resource and occasion for the economic development of a country. Estimates made by the Venice Laboratory of Culture – a work group that coordinates the activities of public and private organizations in this sector – have shown that cultural tourism yields a turnover of about one billion dollars and that there are

about 6000 people working in this sector.

Venice can and must accept the challenge. The city has always been a development centre for the arts and can still play this role. Palazzo Venier Leoni, home of the Peggy Guggenheim museum, is a symbol of this incomplete, but for this reason still open and dynamic, identity. Building of this unfinished palazzo, which is decorated at water level with lions' heads made of Istrian stone, began in 1748 to a design by the architect Lorenzo Boschetti, but it was never finished, probably for financial reasons. The

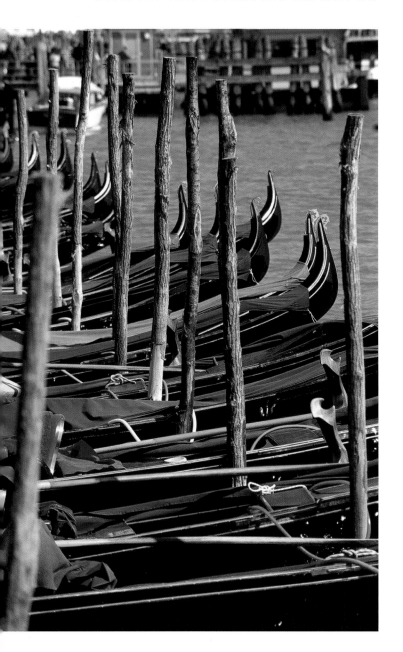

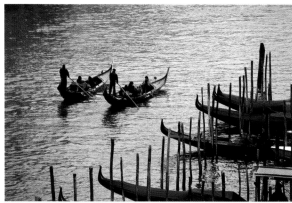

42 The gondolas moored along the Grand Canal clearly show the great attention paid to the construction of every part of the boat.

Note the iron prow, whose likeness to musical notation reminds one of the splendor of Venetian Baroque music.

planned upper floors were to have been modelled on the triple arch of the lower floor, which is now covered with ivy. The classical façade was intended to act as a dissonant counterpoint to the Gothic *palazzi* on the opposite side of the Grand Canal. From 1910 to about 1924 the building was owned by the eccentric marquise Luisa Casati Stampa, an egocentric and charismatic person who attracted the cultural elite of the time to her salon, including such figures as Boldini, Van Dongen, Arturo Martini, Marinetti, Boccioni, Ravel, Fortuny and Man Ray, to mention only the most famous. The writings and art works left behind by the artists who visited and portrayed her highlight the most sensational aspects of her life: her passion for occultism, exotic animals and unconventional dress, and her excessive use of drugs. Peggy Guggenheim, a sensitive art collector who during her career was a close friend of some of the leading twentieth-century artists and writers, including Brancusi, Duchamp and Beckett, bought the house in 1948. This was the year when the Venice Biennale exhibited her collection of Cubist art, which in 1942 at New York had constituted the revolutionary Art of This Century gallery-museum. This innovative exhibition space, which projected out of the canvases the abstract and Surrealist space dreamed of by the leading twentieth-century artists, was conceived by the Austrian–Romanian architect, Frederick Kiesler. By then the collection was basically the same as the one we can admire in Palazzo Venier, where photographs, drawings and Kiesler's original designs for the gallery-museum in New York were recently assembled and exhibited. The Venetian house-museum where Peggy Guggenheim lived for the rest of her life – which also houses the Gianni Mattioli collection – has an incredible 'anthology' of twentieth-century art: the diversity of the works is

43 *The Column of St Mark, together with that of St Theodore, represents the ancient Roman and Byzantine origins of Venice. The Venetians' love of St Mark gradually replaced their devotion to the Greek saint as the Republic was becoming independent from the Byzantine Empire.*

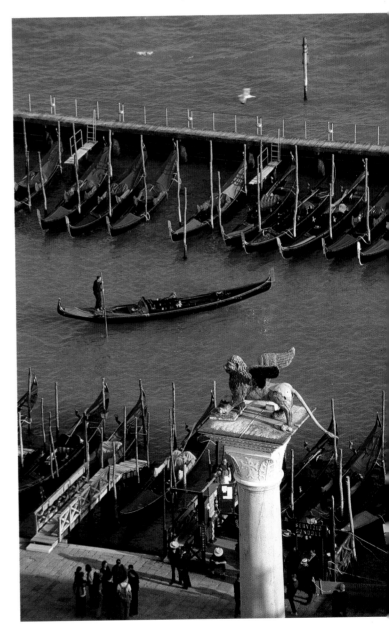

endless, ranging from the Cubism of Picasso and Braque in the dining room to the Futurism of Severini and Balla in the kitchen, Mondrian's and Kandinsky's abstractions in the living room, and the Abstract Expressionism of Pollock in the guest room. But there are also works by Klee, Magritte, Dali, Miro, Chagall, De Chirico and Modigliani. No list of artists and works would suffice to describe the treasure trove of art that Peggy Guggenheim purchased.

Venice is therefore a city of contemporary art, and not only within the context of the Biennale, which since 1893 has represented avant-garde art in Italy and the rest of the world, the art that in

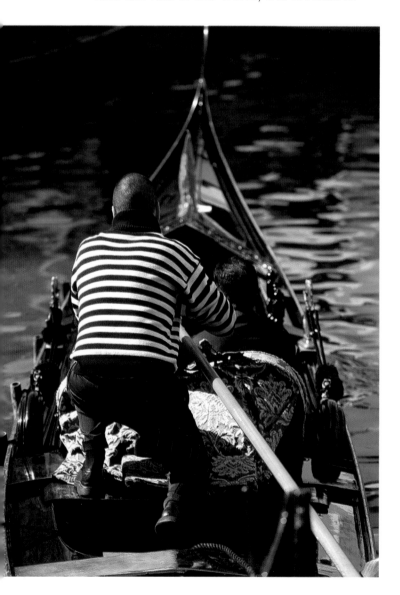

different ways – some of them eccentric and obscure – has sought to break with tradition. Venice is a contemporary art city in the sense of art works that are contemporary to us, alive, 'in progress', cast into existence and precisely for this reason receptive to the future. When we pass through Venice we see splendid works of art, the mature fruit of formidable genius. It is where great artists expressed their tastes and visions of the world as if they were precious jewels. In Santa Maria della Salute, the volute buttresses and figures of saints whose back parts were left unfinished, embody in a single view the twofold truth expressed by Baroque art: the knotty problem of reality and appearance, matter and form. Opposite the Scuola Grande di San Marco is the majestic equestrian statue of Colleoni, modelled so finely in bronze by Verrocchio. Blazing in this cold metal are the pride of the great condottiere as well as all the power of the already mature Renaissance; in that flourishing period the human being was considered the crux of history, the very measure of the cosmos, the heroic maker of his own destiny.

Emerging from the alleys and streets into St Mark's Square, the shapes of the basilica, like the sound of bells on a festive occasion, announce the political centre of the doges' Venice and the heart of the present-day tourist city. Hordes of visitors – both seduced and bewildered by the magnificent sight – are irresistibly drawn there. However, the uniqueness of Venetian art does not derive from the mere quantity of its impressive, singular monuments, but is rather generated spontaneously in the city itself. Uprooting these works from their context would he tantamount to removing the vital organs from a living creature. This is the reason why Venice can be understood only in its overall unity.

None of the great Venetian works can be conceived outside their context as self-sufficient. Each lives in a relationship with

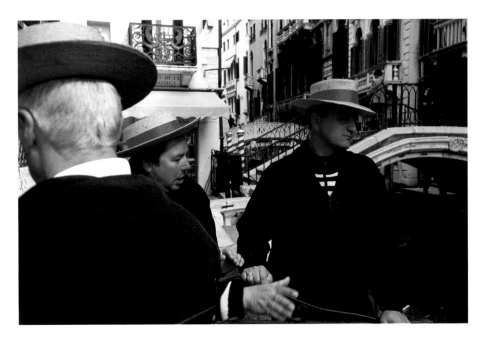

44-45 Admittedly, a gondolier's work is hard, but there is always some time during the day for relaxation.

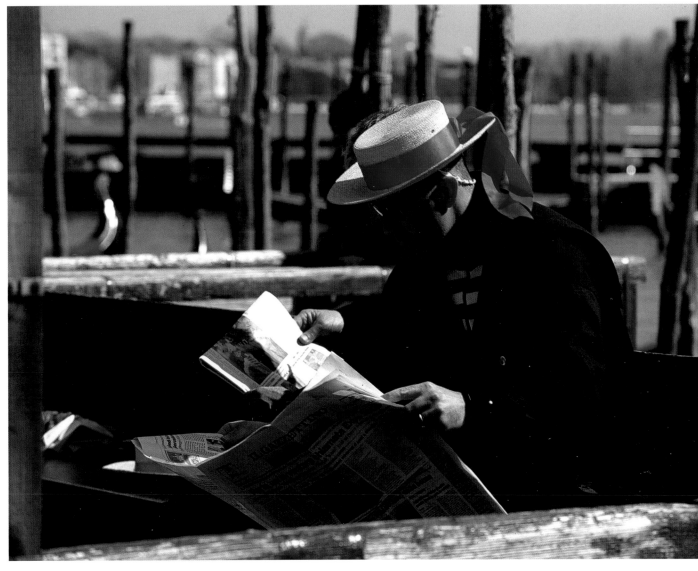

its neighbour in an organic and symbiotic concatenation that takes in the entire lagoon area. The focus of our lens therefore shifts from the buildings to what links them in a figurative continuity: the rhythm of the unpredictable succession of canals, squares and alleys on the overall continuum of the lagoon, a restless surface of many shapes. Like the basso continuo in a Baroque concerto, they support the harmony woven by the alternation of soloist and orchestra. When we stroll through the calli and campi or cross over the canals, we perceive a hint of perpetual movement that merges forms and colours; in the city, opposite, around and through us, a space takes on form, a space that is above all light. However, we must not

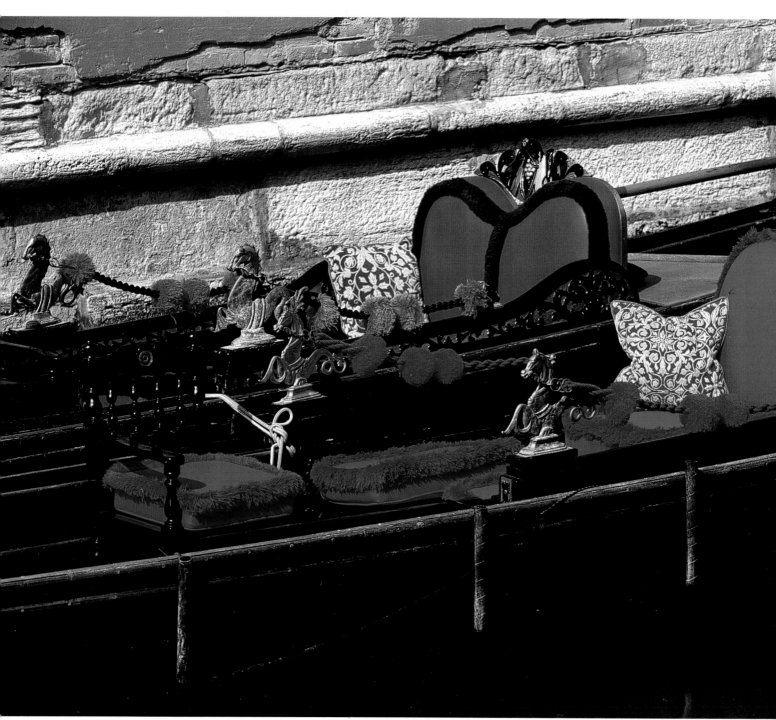

46-47 Gondolas are part and parcel of the cityscape: along the canals, their shining surfaces and brightly colored damask contrast with the peeling plaster and porous bricks of the buildings.

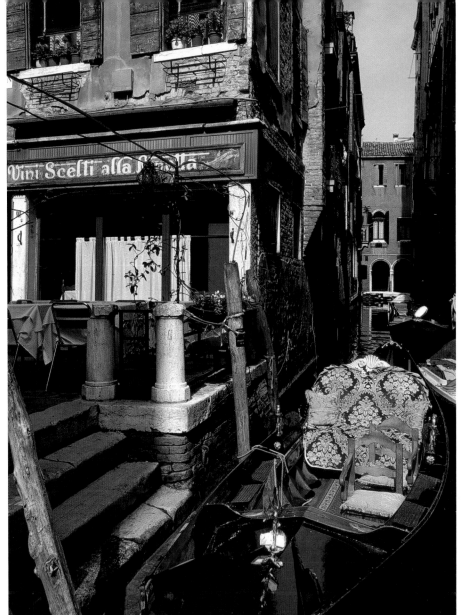

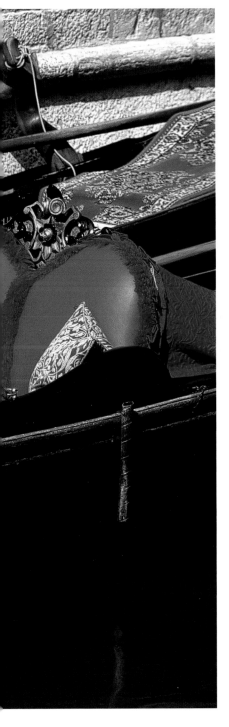

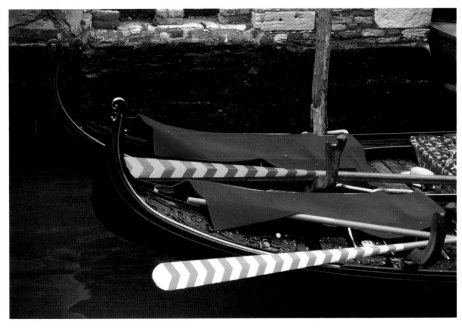

think that all this is the result of chance, since in Venetian architecture we can recognize styles and architectural solutions that demonstrate the continuity of age-old knowledge and wisdom. Let us pause for a moment on the Grand Canal to observe the points at which the smaller canals begin. Note that the corner buildings have oblique sides, which highlight the continuity of the surface of the canal walls and draw our attention away from any sense of divergence or break that the junction might create.

Skilful Venetian builders were able to replicate within the walls of the city the dimensions that the Byzantine architects had achieved in their churches. Like the interior of a basilica in Ravenna, they seem to have created outside spaces in the city of Venice by casting gradual and continuous flows of light onto the

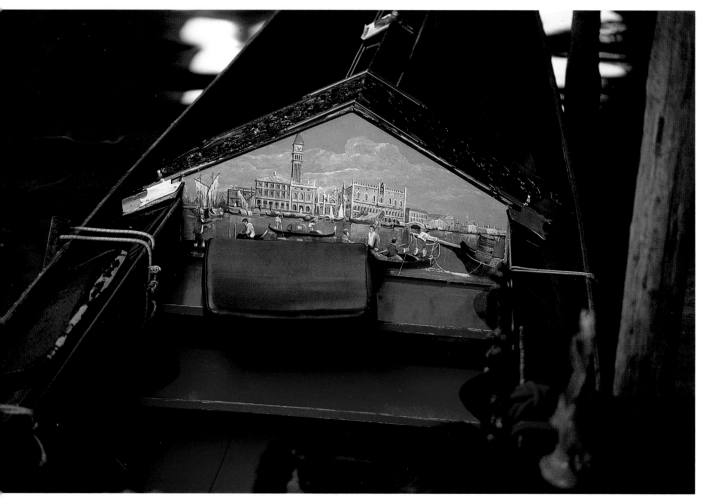

48-49 Gondolas are still the most popular symbol of Venice, and their rich, often self-referential decoration underscores their close bond with life in the Lagoon and maritime life in general.

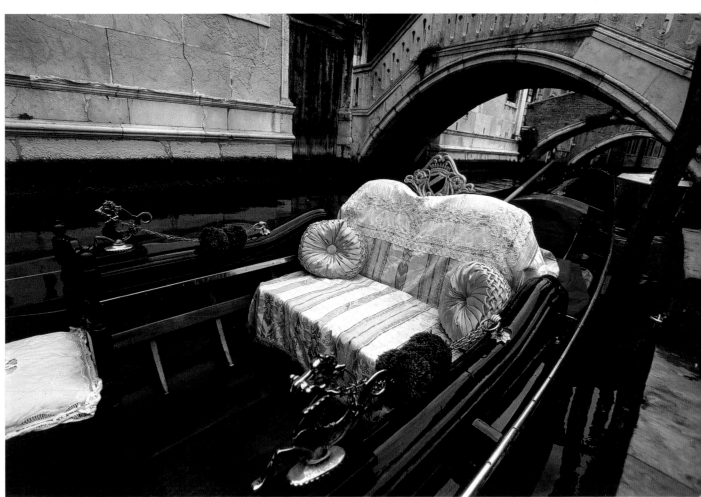

50 above Sometimes it is the crowds of tourist that attract the gondoliers' curiosity, and not vice versa.

50 below This retired sailor combines business and pleasure by making model boats that he sells in his stall.

51 Gondolas are not the only picturesque boats one sees in Venice; this is a "romantic" variation of the historic S'ciopon, which is rowed with two rows.

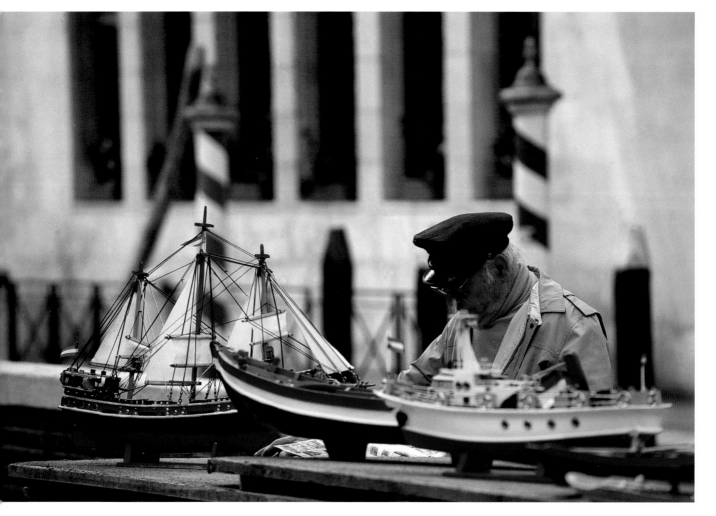

50

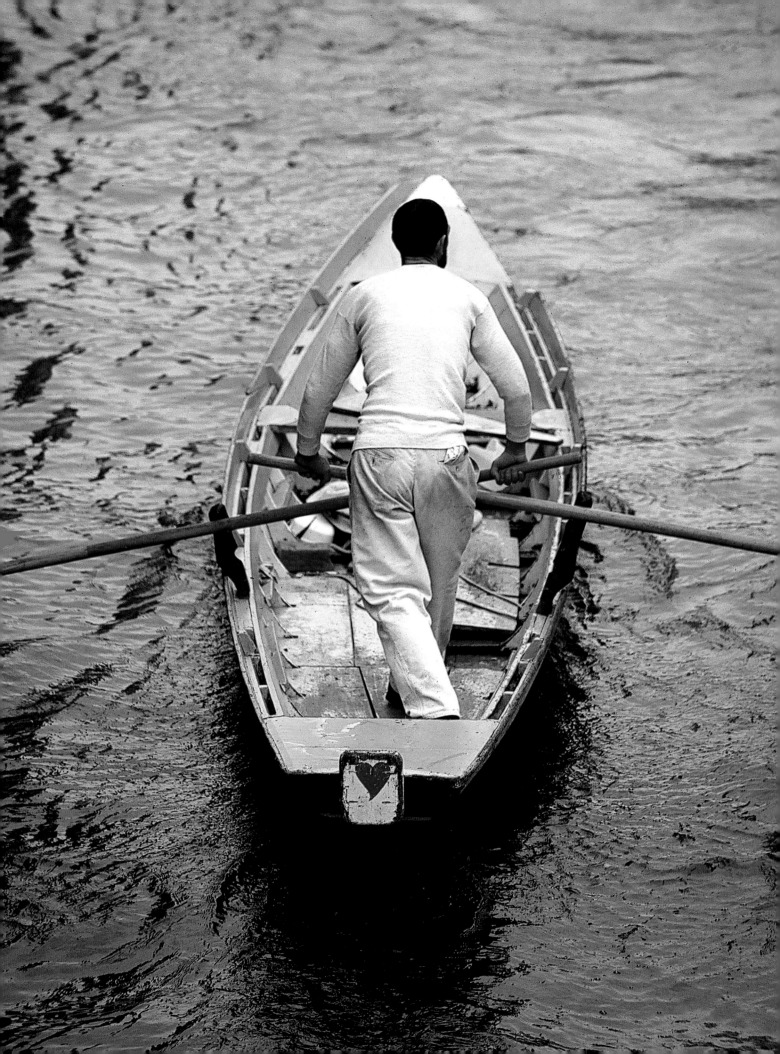

shadows. Venetian architects had wrested from God the luminous, superhuman spatiality that Byzantine art had invented. Venetian art is a continuation of Byzantine art, not only in the sense that it is derived from it, but also and especially because the great cultural patrimony, transmitted through Ravenna and experienced directly in Constantinople, was revived and re-elaborated in original forms in a different cultural climate and in a different society. Byzantine art, through the cold brilliance of its mosaics, the abstraction of its forms, and its highly intellectual symbols, expresses the divine transcendence and intangible superiority of the empire. With soft, warm, harmoniously blended colours that envelop the entire setting, Venetian art expresses serenity and calm, the awareness of the political and economic superiority of a city, its people and its civilization.

The typical façade of a Venetian *palazzo*, a residence with towers (*torreselle*) on each top corner, derives from late Roman times: from the year 1000 to the eighteenth century, such a *palazzo* always consisted of a multiple arched loggia with fretwork set between two plain side walls. This style derived from the façade of a Roman villa, which also always had a central loggia and towers. Many examples of it have been reproduced, especially in African mosaics, and we can now trace its entire evolution.

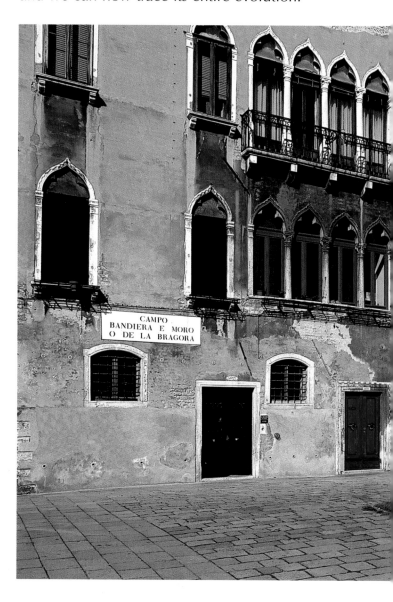

52 The squares of Venice are like theaters in which the locals and tourists alike play their role: here we see a young Casanova in Campo Sant'Angelo.

52-53 The "three ages of Man" are captured in this photo.

53 Something has piqued this old Venetian's curiosity.

Venice inherited the late Roman style as it developed along the Mediterranean coasts from Byzantium through to Ravenna. As it developed over the centuries, the style seems to have assimilated something that intrinsically captures the sea. In their translucent clarity, the islands in the Venice Lagoon – with their treasured labyrinths, complex networks of churches, and buildings etched with fine inlay and tesserae – give the impression that the ebb tide has just left layers of dry gravel, multicoloured pebbles, and pieces of shells that have retained in their patterns the curve of the waves.

Venice found an almost unlimited economic resource in the sea and in the

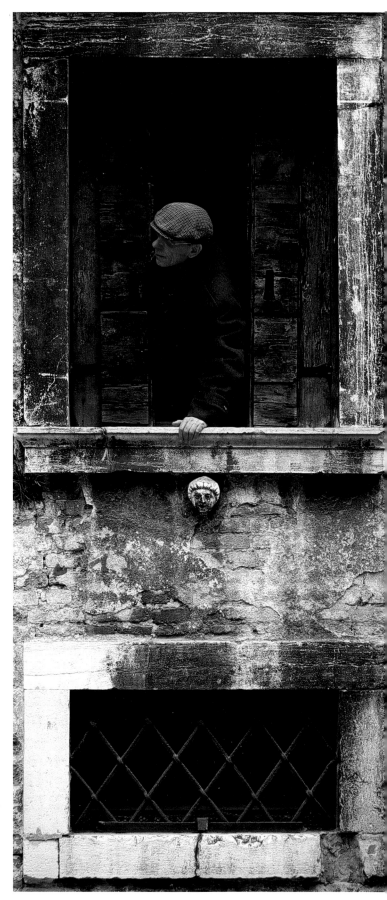

In Venice, architecture and town planning are one and the same, and interiors and exteriors can often be mistaken for one another.

54 Light falling on the stairway and well in the courtyard of Goldoni's house.

54-55 The light also penetrates the canal and illuminates a typical bridge in the San Marco district.

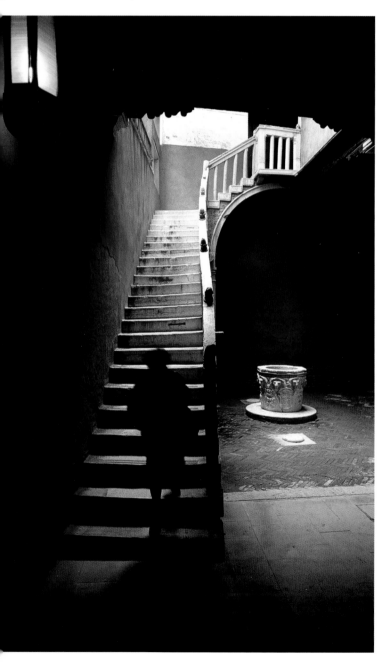

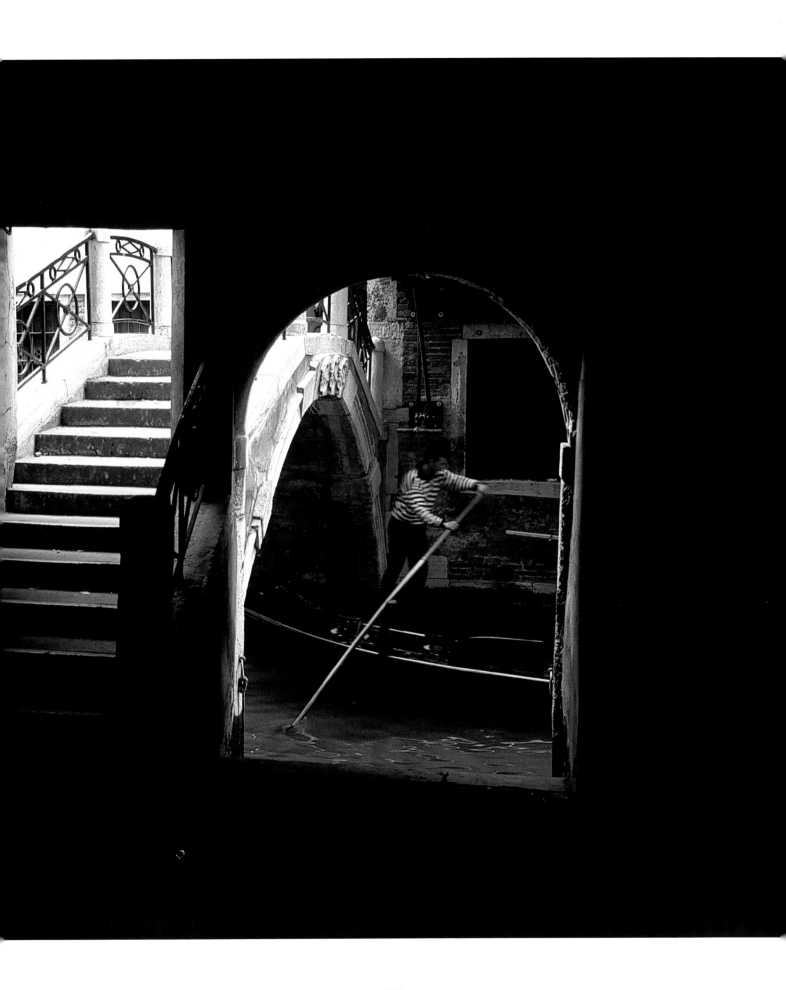

position it occupied geographically. It soon became apparent that the city was located on a major seaway to Byzantium and the East with control of the sea, Venice was able to engage in trade and the city began to import silk, carpets, precious stones and spices, while exporting salt, glass, timber, wheat and wine. The Venetians soon started to build a host of small 'Venices' along the full length of the Adriatic and Aegean coastlines, from Zara to Cyprus, and along the coasts of Asia Minor. There, in the name of the Venetian Republic, they established warehouses and trading stations. They began to

engage in commerce and to form political alliances that remained untouched by any ethnic or religious prejudices. This extremely active trading network generated complex forms of communication that involved exchanges not only of men and merchandise, but also of customs, ideas and artistic styles. Although Venice came to be regarded as the westernmost city of the East, we should not take this to mean that Oriental models were merely transposed to the lagoon. Venetian architects never slavishly copied Oriental buildings; rather, they assimilated different styles or models and

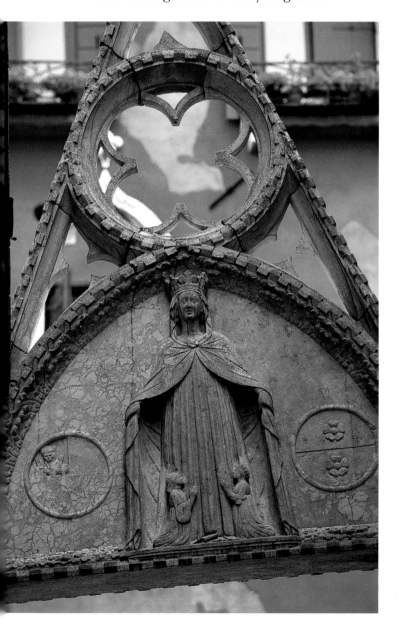

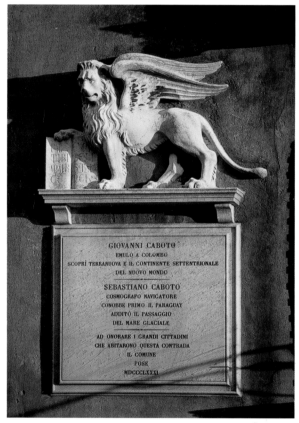

then merged them, thus creating an organic and coherent style in which Oriental influences took on a new meaning and served a new purpose.

From the very beginning, Venice and Venetian art favoured a complex artistic vocabulary of beautiful, transient symbols that could multiply, interweave and decompose. The image of Venice springs

Interesting bas-reliefs on the walls of the buildings represent the power and institutions of the Most Serene Republic.

56 left In the Arco del Paradiso, next to the Virgin Mary, the image of the Church, are the coats-of-arms of the Foscari and Mocenigo families.

56 right The winged lion represents the Venetian Republic.

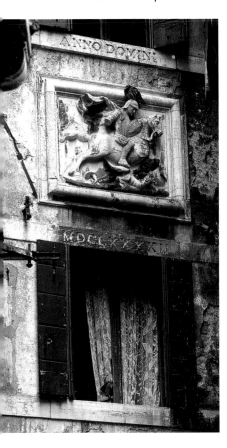

57 St George slaying the dragon was, among other things, the symbol of the prosperous Dalmatian community in Venice, which in the mid-15th century founded the Scuola di San Giorgio degli Schiavoni.

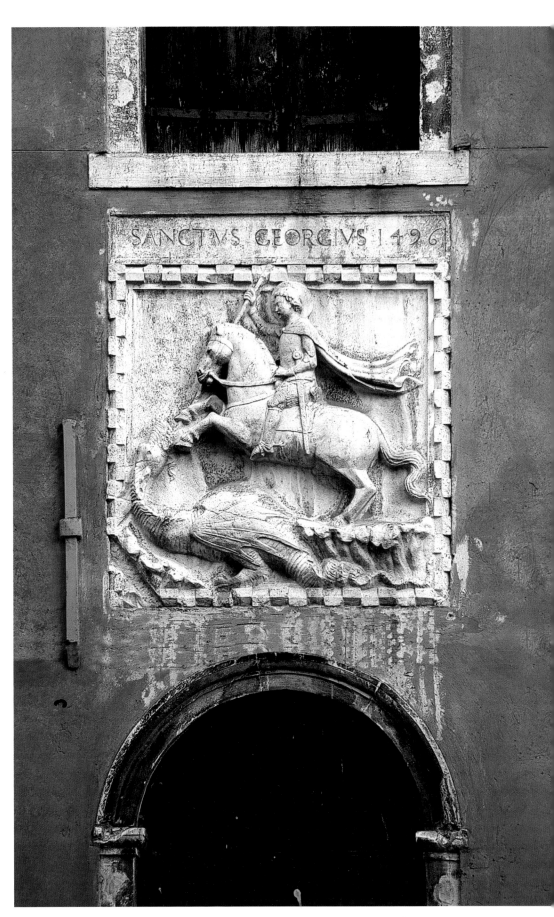

SANCTVS GEORGIVS 1496

up at the point where water and sky meet: a place of unlimited dimensions and unadulterated surfaces of pure colour. The secret of Venetian art does not lie in a complicated figurative formula or code, but rather in something that is really quite simple – the wholly natural capacity of water to reflect light. The water infiltrates light with particular effect in the maze of canals. It washes the *palazzo* and is transformed into a fluctuating, labyrinthine mirror in which the forms

58 *A grotesque mask glares at us from a wall of the Scuola di Nicolò dei Greci, now the home of the Icon Museum of the Greek Institute.*

58-59 *This proverb in Latin is an example of local humor: "Fish begin to smell from the head".*

59 *above Elaborate floral motifs, carved in stone or molded out of clay, are to found everywhere, decorating the churches, buildings, streets and alleys of Venice.*

PARROCCHIA D[I]
S.ZACCARIA

RUGAGIUFFA

SOTOPORTEGO
FOSCARA

and colours of each building are reflected in a liquid state. It is a mirror that is changeable, animated and unique. It is unpredictable because of the varying intensity and direction of the wind, and is continuously interrupted by the movement of bodies and boats. Everything that is reflected, but particularly the sky, is refracted and broken down as if filtered by various prisms; it merges with the reflections of the neighbouring buildings, which in turn merge with yet other edifices in an unending flow. Light and diaphanous,

60-61 Near the Rialto Bridge is the lively market in the Campo della Pescheria, which offers fish caught in the Lagoon and the sea. The column capitals of the elegant roof have sculpted boats, fish pots, human faces and fish. Fishing has always been one of the main sources of livelihood in the Venice Lagoon and helped to support the city's large population.

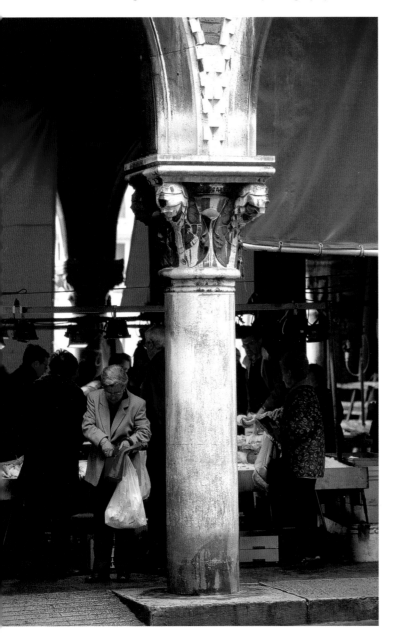

Venetian architecture dissolves and changes forms into weightless images; all the buildings are subtly perforated in a play of light, shadow and fine relief. The ray of light strikes the stones and is reflected in atomized forms that are blended into manifold ephemeral impressions. "[…] To come to Venice by the station is like entering a palace by the back door," says Thomas Mann in *Death in Venice*. And he adds: "No one should approach, save by the high seas, […] this most improbable of cities." The bare, lucid stairs of the railway station cast us alongside the Grand Canal, more or less on a level with the Scalzi Bridge. Thus we enter the Cannaregio district, on the road that was built to modernize the town in the nineteenth century. Wholly out of proportion with the *calli* or narrow streets that face it, the Lista di Spagna takes us quickly to Campo San Geremia, where we

62-63 Boats were the means that made it possible for humans to adapt to living in the Venice Lagoon and consequently were responsible for the birth of Venice itself. Here are some examples of modern boats against the backdrop of the mossy walls of the historic buildings.

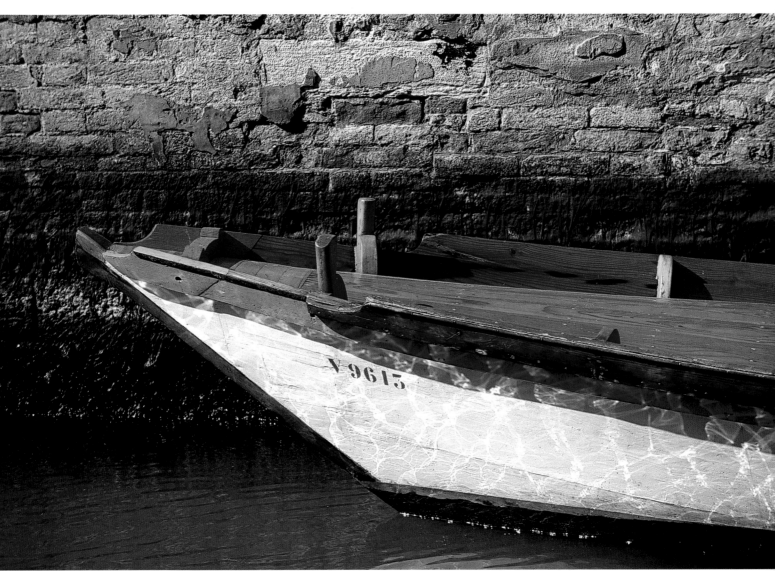

V 9613

see the white church with its Greek cross and lovely bell tower made of red bricks. This striking contrast attracted Francesco Guardi, who painted a splendid canvas in which the district is viewed from the Grand Canal in its eighteenth-century guise. It is now difficult to recognize the site Guardi painted because everything, except for the slender campanile, has changed. The wide street continues past the Ponte delle Guglie. If you stay on the elegant but rather anonymous Lista di Spagna, perhaps attracted by the comforting signs that promise an easy walk to the Rialto and St Mark's despite the maze of Venetian alleys, you run the risk of seeing very little of the true Venice. This is because its authentic beauty vanishes amid the mesmerizing clamour of the crowds. In fact, to appreciate the features that characterize the complex and fragile identity of Venice it is essential to get away from all this. And, when all is said and done, that is not difficult to do. Once past the Guglie bridge, you need only take the *fondamenta* (a street along a canal) on the left and then look for a dark *sotoportego* (an arcade that goes under a building) to arrive at the most ancient ghetto in Europe, now a fascinating and peaceful neighbourhood. Off the beaten tourist path, yet part of the itinerary of any school field trip because of its important Jewish museum, this quarter, which seems so simple and humble, is now enjoying a slow revival. Various restaurants offer kosher specialities; little shops sell postmodern handicrafts; and there are also a number of small workshops. One may even come upon an elderly rabbi or a 13-year-old boy as pleased as punch to be having his Bar-Mitzvah, the ceremony that marks his entrance into adulthood.

From the Strada Nova, on the other hand, you need only cross over Campo Santa Fosca to discover a stupendous area marked off by three wide canals. Running parallel to one another, these canals frame a string of *palazzi* and blocks of less elegant buildings, churches and convents, all lined with luminous streets. These beautiful stone-paved *fondamenta*, interrupted by old and recent bridges, all converge towards the middle of the district and lead us, through the Ramo della Misericordia, to where the Cannareggio narrows and becomes a welter of alleys, short streets and *sotoporteghi*. Here we are already on the edge of Castello, Venice's highly picturesque working-class district. From here, by crossing Calle Larga and Campo dei Mori, we reach the most secluded area in Castello. This is the Madonna dell'Orto church, a noteworthy example of late Gothic religious architecture with its original floor made of terracotta tiles in a

herringbone pattern that is still preserved. It also boasts two huge canvases by Tintoretto, which the great artist donated to the church. Not far away, near the Jesuit convent and Fondamenta Nuove, where the lagoon and its islands appear before us, the streets become straight and perpendicular and are lined with small houses. Here we note the pragmatic, rational approach to town planning that is so often found in working-class quarters, but the warm light and silence transform its space. The profiles of the boats on the horizon at Fondamenta Nuove, the

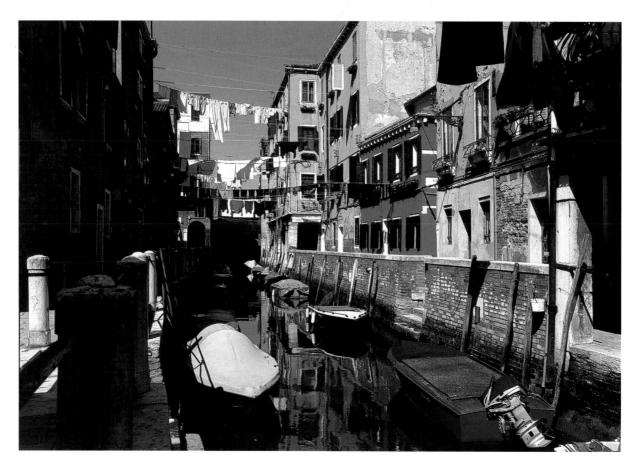

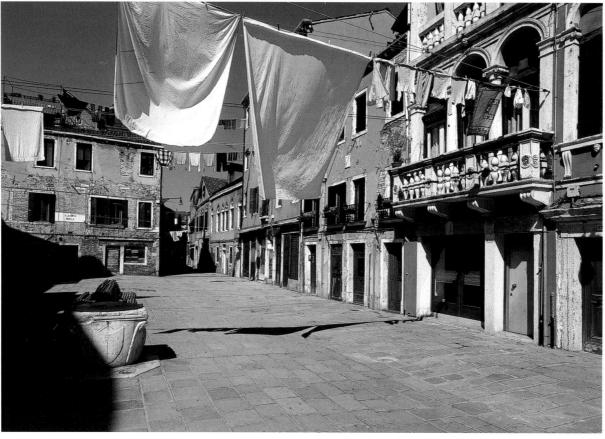

landing stage for trips to and from the islands, evoke dreams of a whole empire modelled entirely on Venice. Were that to be the case, one would want to visit all the islands – where time seems to have stopped at an indeterminate point in the middle of a dream – and then take a ship past the lagoon in search of every trace of Venetian civilization.

From the Fondamenta Nuove you can soon get to the Castello district by passing over the wide Rio dei Mendicanti, which flows into the broad canal facing San Michele, the island that serves as Venice's cemetery. One often spots a funeral boat on this waterway, an unusual variation on the theme of our fragile and transient nature. By going along the Rio you will come to the church built from the thirteenth to the fifteenth century and dedicated to the Roman martyrs John and Paul (Santi Giovanni e Paolo). The various building phases are easy to distinguish on the façade. The white fifteenth-century portal, which was never finished, is a tribute to the burgeoning Renaissance and is framed by elegant columns; it spills over onto the austere blind pointed arches that divide the lower part of the façade into seven sections. The narrow arches, which are austere funerary chapels of doges, lead our eye upward, where the Gothic façade gives way to sixteenth century geometric forms. The side of the church facing the square has various elegant chapels. Tall pointed arches cut through the apse and offer a glimpse of the stupendous colours of the stained glass windows. Known as the Pantheon of Venice, this church houses the memory of outstanding civil and military figures of the Most Serene Venetian Republic.

At Castello you will see some of the highest expressions of the Venetian Renaissance. Toward the end of the fifteenth century the rich and powerful brotherhood of the Scuola Grande di San Marco, which some Venetian families founded in 1260 as an expression of their

64 above The clothes hung out to dry so meticulously in the alleys and squares are veritable banners; the simplicity of everyday life becomes the "flag" of the working class districts.

64 below The buildings facing Campo Ruga include a white 16th-century palazzo.

65 This canal in the Castello district is like a ship fully decked out with its flags.

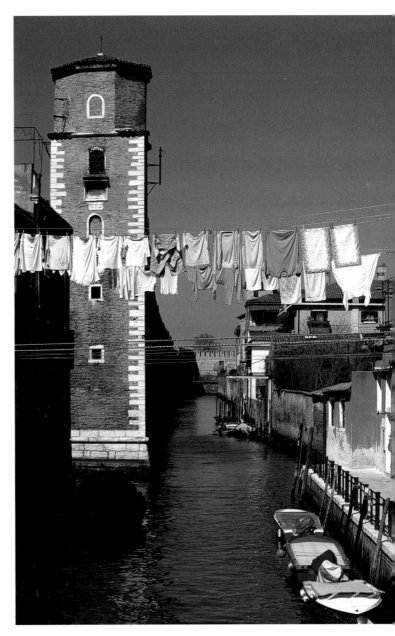

66 above The slender bell tower of the Chiesa dei Carmini is a splendid example of the continuity between medieval and Renaissance architecture.

66 below San Salvatore Church boasts a bright, spacious Renaissance cloister.

67 Among other things, Palazzo Contarini is famous for its magnificent spiral staircase (the so-called bovolo), designed by Giovanni Candi.

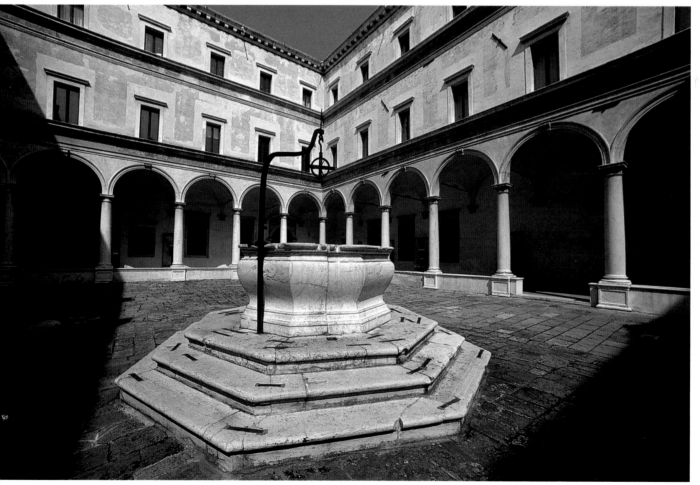

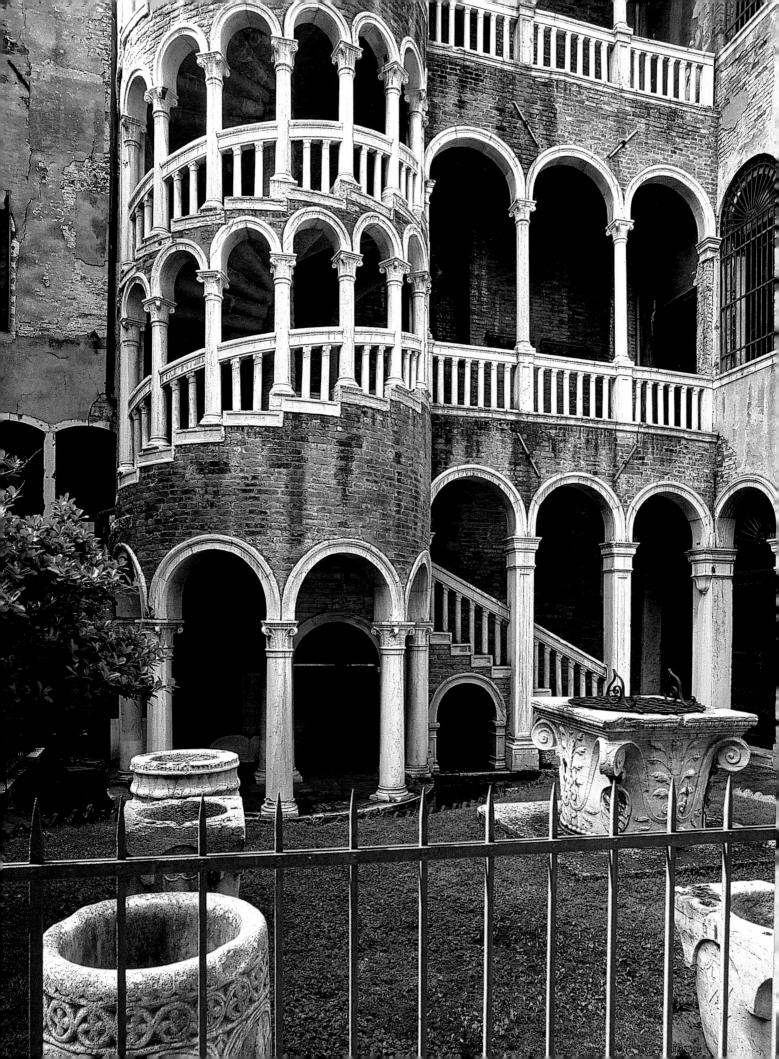

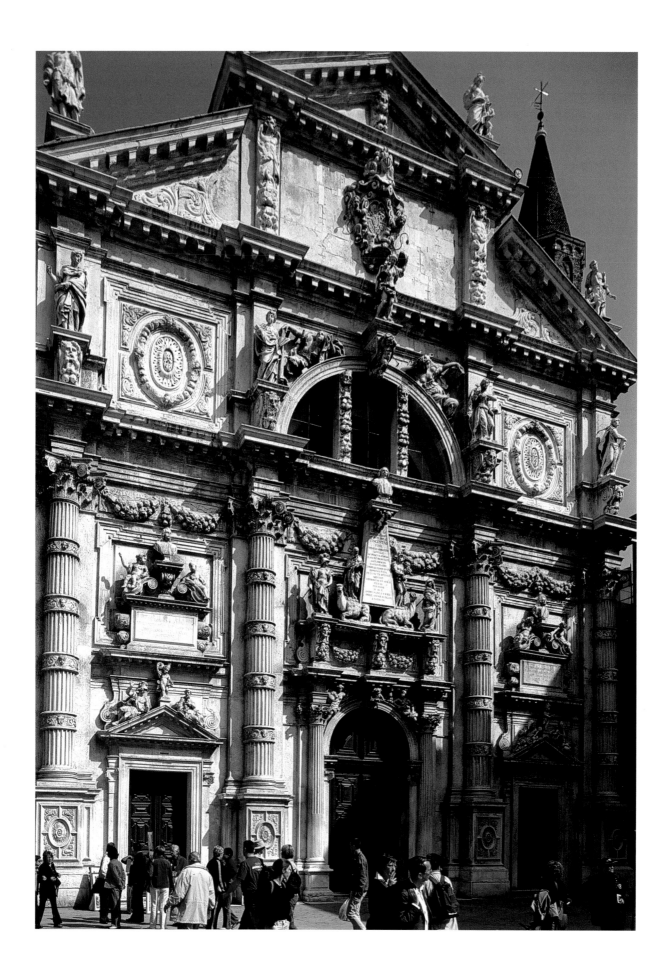

religious piety and worldly interests, decided to leave Santa Croce Church, its original headquarters, and construct a large and splendid building that would be a worthy home for the many brothers. The richness and beauty of the Scuola Grande was such that, when fire destroyed the new building a few years after its completion, the brotherhood immediately established a building yard under the supervision of Pietro Lombardo. The superbly articulated marble façade is further distinguished by the addition of *trompe l'œil* loggias, which in turn are crowned by round arches connected by

elegant pilaster strips. There is a play here on perspective representations – friezes and polychrome marble – that lighten the masses. The architect, Mauro Coducci, topped the façade with curved pediments embellished with statues of saints, an architectural element that had already been used in the nearby church of San

68 The lavish façade of San Moisè Church, which marks the triumph of Baroque architecture, cost the aristocratic Fini family 30,000 ducats.

69 left Perhaps because of its abundant decoration, San Moisè has never been a favorite with the Venetians.

69 right The Scuola di San Fantin has a much more austere appearance.

70 In 1630 Baldassarre Longhena was asked to design the Santa Maria della Salute basilica to thank the Virgin Mary for having rid Venice of the plague. The 32 year-old architect created one of the masterpieces of the Baroque period.

71 The equestrian monument of King Vittorio Emanuele II along the Riva degli Schiavoni.

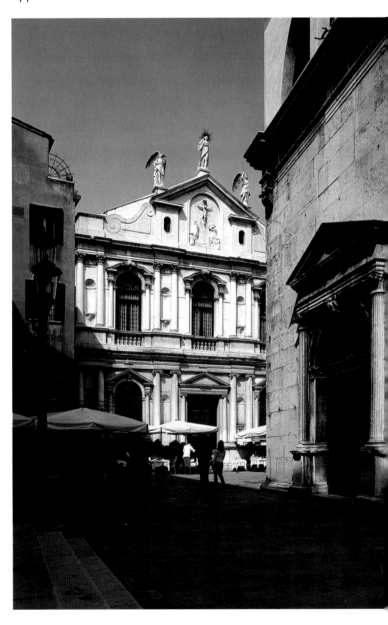

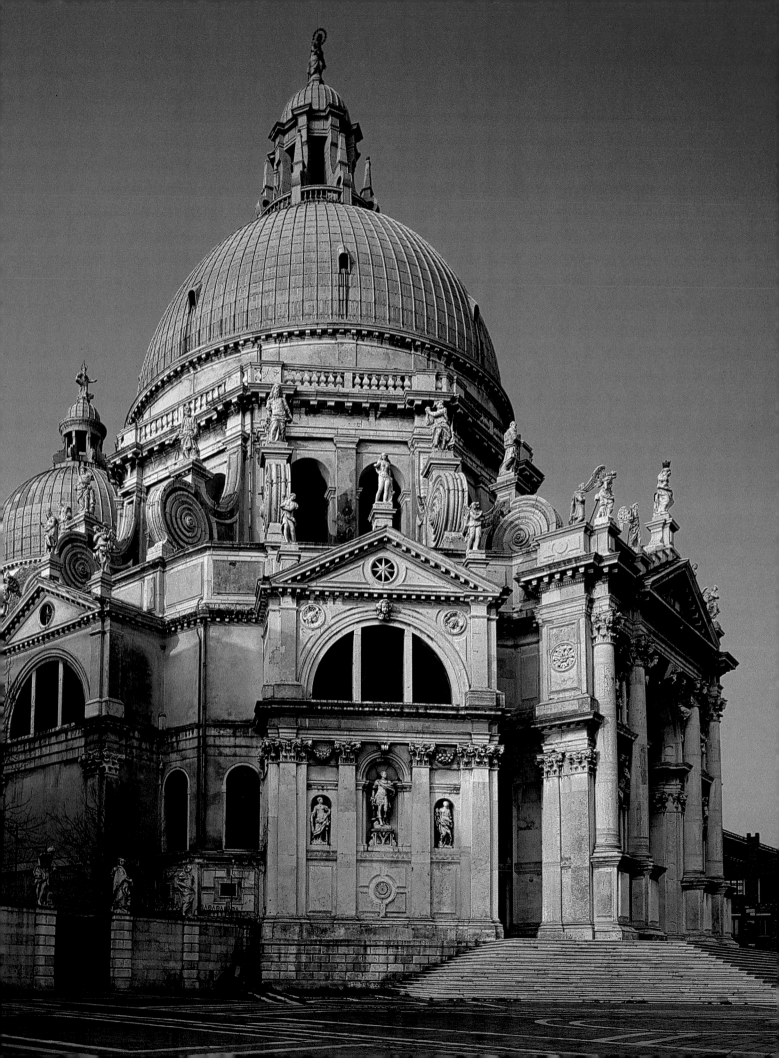

72-73 At the eastern
tip of Venice, in the
Castello district, lies
San Pietro island,
dominated by the
church of the same
name, which is
flanked by a curious
leaning campanile.
The district was named
after the fortress that
once towered over
the island.

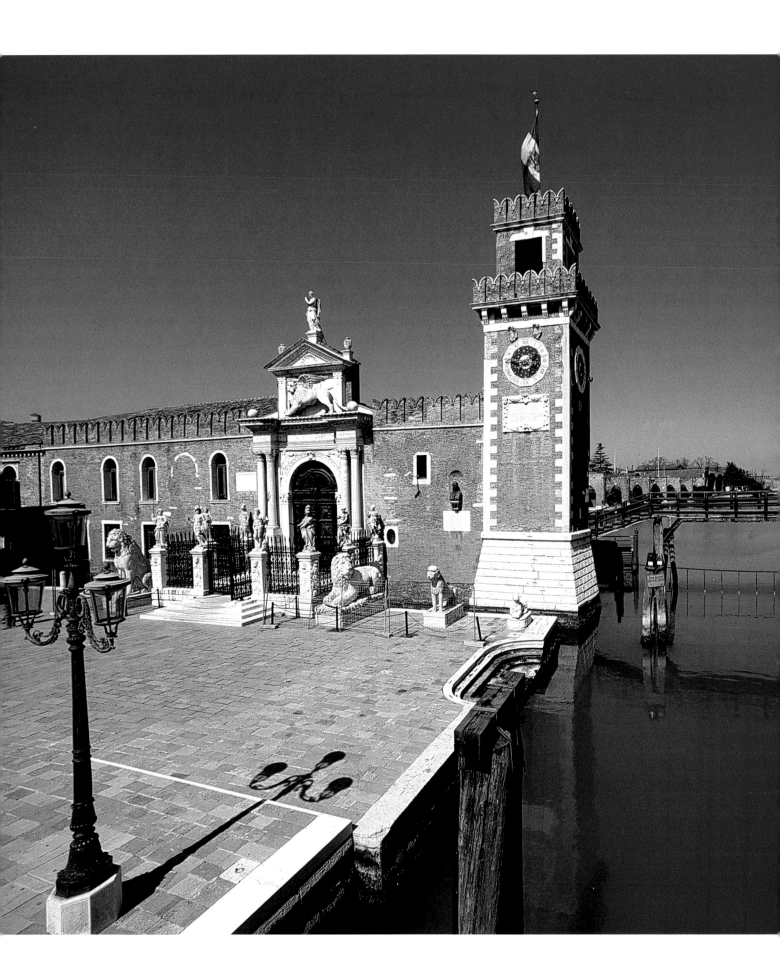

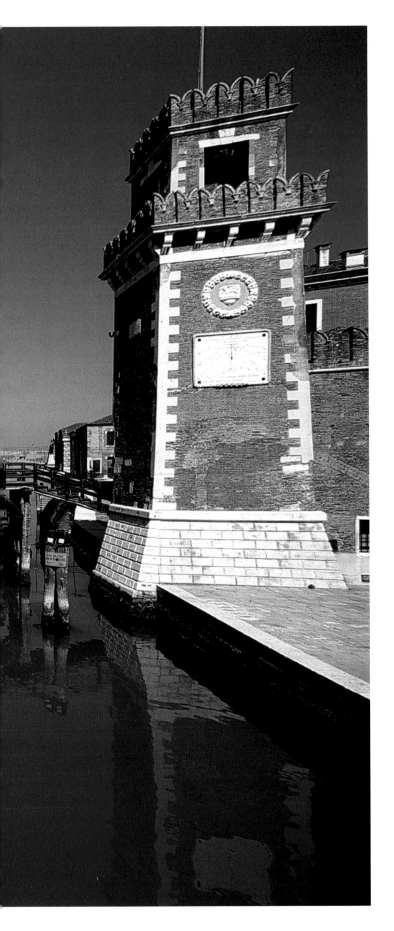

Zaccaria, which employs the arched motif of *trompe l'oeil* loggias and windows within a more compact and clear-cut framework. Coducci no longer used coloured marble, but achieved the same effects by working on the surfaces and exploiting the infinite play of material and light. Bartolomeo Colleoni, with a tense Leonardesque expression but once again on horseback after recent restoration work, dominates the square in front of the Scuola.

Coducci's artistic principles were adopted by Sansovino, who became the principal interpreter of the architectural revival in Renaissance Venice. In his most important work, the San Marco Library, he transformed the body of the edifice into a pictorial plane, a surface that both encloses and opens out an inner space. Only Palladio would surpass this Tuscan architect in fame and fortune. Again in the Castello district, the church of San

74-75 The Arsenale, founded in the 13th century and rebuilt several times, was the huge shipyard complex that built the fleets that made the Venetian Republic a great maritime power.

75 right On one of the two massive 16th-century crenellated towers that guard the entrance to the Arsenale is the large face of a centuries-old clock.

Francesco della Vigna bears witness to the alternation in the fortunes of these two artists. Initially, the construction of the church was entrusted to Sansovino, but in 1564 the Patriarch of Venice, Giovanni Grimani – a sophisticated intellectual and urbane collector of ancient art works who had shortly before been acquitted in an insidious heresy trial and was now seeking acknowledgment and recognition from the cultural elite of the Venetian patrician class – commissioned Palladio to erect the façade of the church.

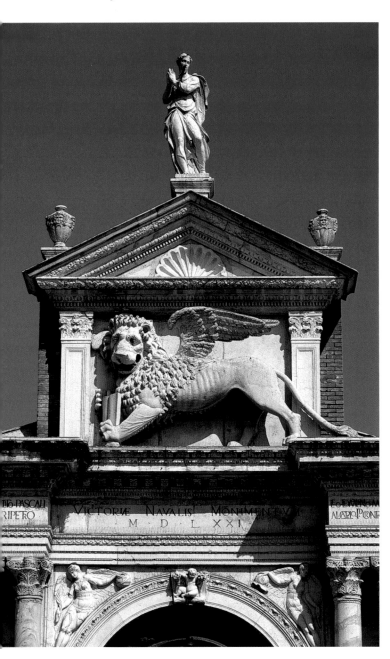

Palladio symbolized the accomplished rebirth of the classical spirit in architecture. From Leon Battista Alberti onwards, Renaissance architects had been engaged in the arduous task of elaborating on the façade of the classical temple – namely a building with a single hall – in order to place it in front of the composite space of the Christian church. Palladio offered the first concrete solution to this problem in the façade of San Francesco della Vigna.

Various forms of Renaissance art can be found in the canal entrance of the Arsenal, which was modelled after the Roman arch of triumph to commemorate the fall of Byzantium in 1453: on that occasion, towers were built to guard the canal entrance and large lions, which may have been brought from Greece and still greet visitors with their sly expression, were placed on either side of the entrance. The Arsenal symbolizes the height of Venetian dominion over the seas. This was the shipyard that built the galleys and large galleasses that allowed Venice to rule the Adriatic, vie with the Turks in the Aegean, and eventually defeat them in the Battle of Lepanto. The first nucleus, which can be documented from the early thirteenth century, consists of two rows of *squeri* or shipbuilders' yards on the sides of the Darsena Vecchia (Old Dock). This was where the large wooden structures that would form the core of the ships were modelled and assembled. In its centuries of development, the Arsenal became the hub of Venetian industry. In its present state it is surrounded by very narrow city canals that were once used as protective moats. The waterways inside consist of the Darsena Grande and the canal, including the Darsena Vecchia and the Bacino delle Galeazze (Basin of the Galleasses). There are shipbuilding yards around the Darsena Grande and Darsena Vecchia, though only three pairs are now able to offer shelter to ships; most notable among these is the elegant Squero delle

76 The majestic portal
of the Arsenale–built in
1460 and modeled
after the Roman Arch
of the Sergi in Pula–
marks a break with
the Gothic style and
is the first example
of Renaissance
architecture in Venice.

77 The terrace facing
the Arsenale entrance,
embellished with
statues of ancient gods
and heroes, was added
in 1682. A short time
later three marble lions
brought from Athens
as war booty were
placed there.

78-79 The original St
Mark's Basilica, which
was like a palace
chapel, was
consecrated in 832.
The remains of the
saint, which had been
taken furtively from
Alexandria, were
housed here. The
basilica was enlarged
and rebuilt several
times, so that it is a
singular mixture of
styles. The façade is
completely cased with
precious marble and
glitters thanks to the
mosaics with gold leaf
ground, almost all of
which were redone in
the 17th-18th century.

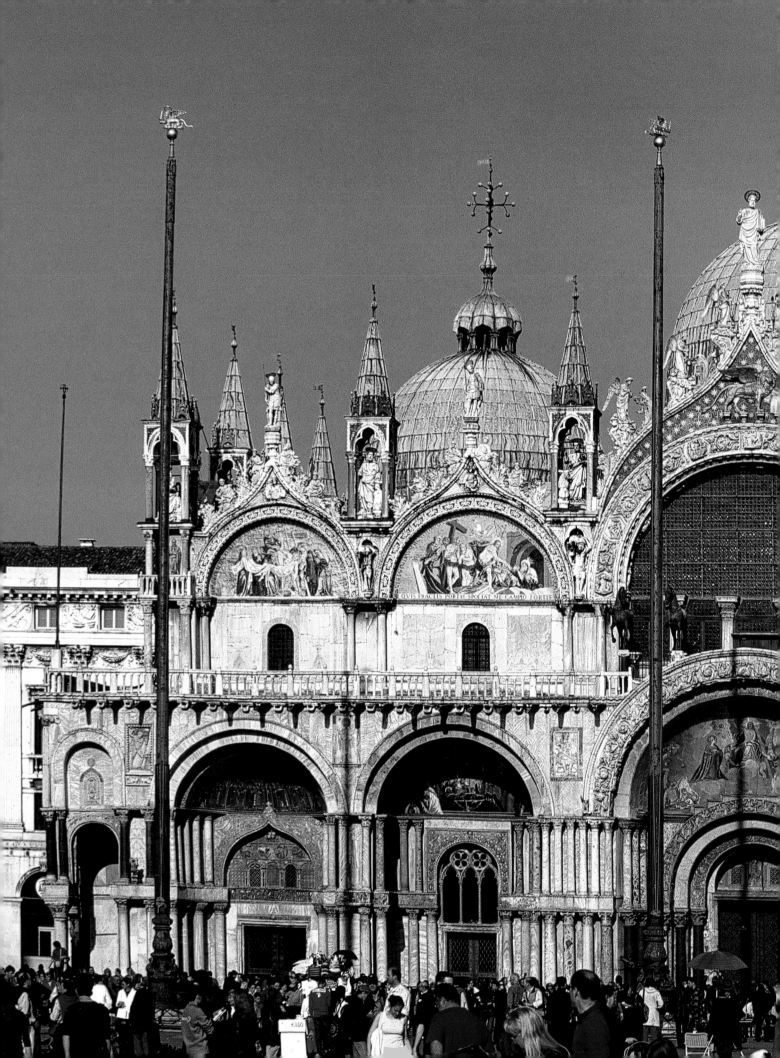

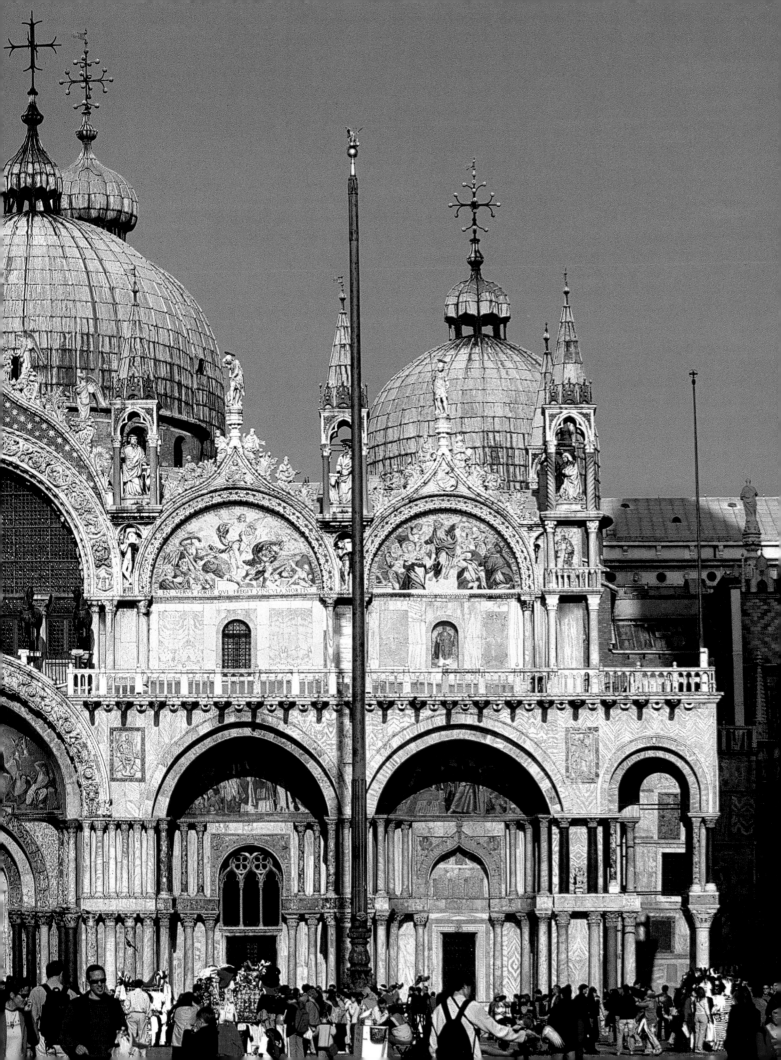

Gagiandre, built in 1570.

Unlike in the streets of the San Marco district, boutiques are few and far between in Castello and even Carnival masks are hard to find there. The shops in this area are more practical; they sell textiles, household utensils and the like. On good days you can rummage about among the bits and pieces at the *mercatino* (little market) in Campo San Martino, or you can stroll through the alleys and streets over which people's washing hangs out to dry – the traditional merry rags of this working-class quarter. There is no end to the corners and views that will attract an attentive visitor: particularly worthy of mention are the narrow Calle delle Muneghette, the broader Salizzada delle Gatte, which suddenly opens out into a colourful area, and the bright Campo Bandiera e Moro, bounded on five sides by beautiful patrician residences, including the fourteenth-century Palazzo Gritti Morosin Badoer. This is the site of the church of San Giovanni in Bragora, where the great composer Antonio Vivaldi, the 'Red Priest' of Venice, was baptized.

Venice is quite a different sight when

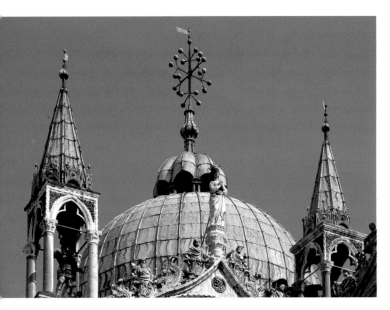

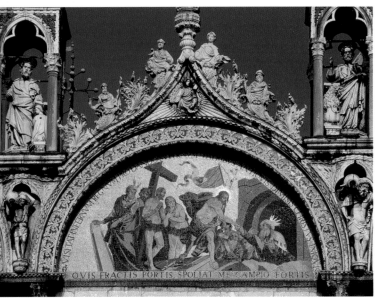

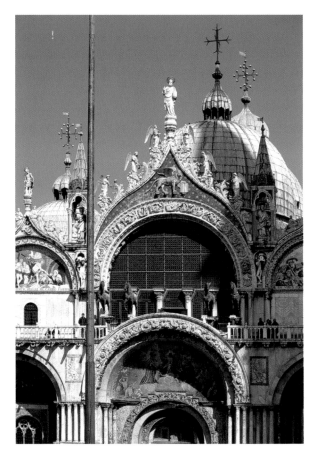

80-81 The façade of St Mark's still has two sets of 11th-century arches, on which various heterogeneous elements were placed over the centuries.

The pinnacles, statues and flamboyant decoration, the work of the Tuscan Lamberti workshop, were finished in the first half of the 15th century.

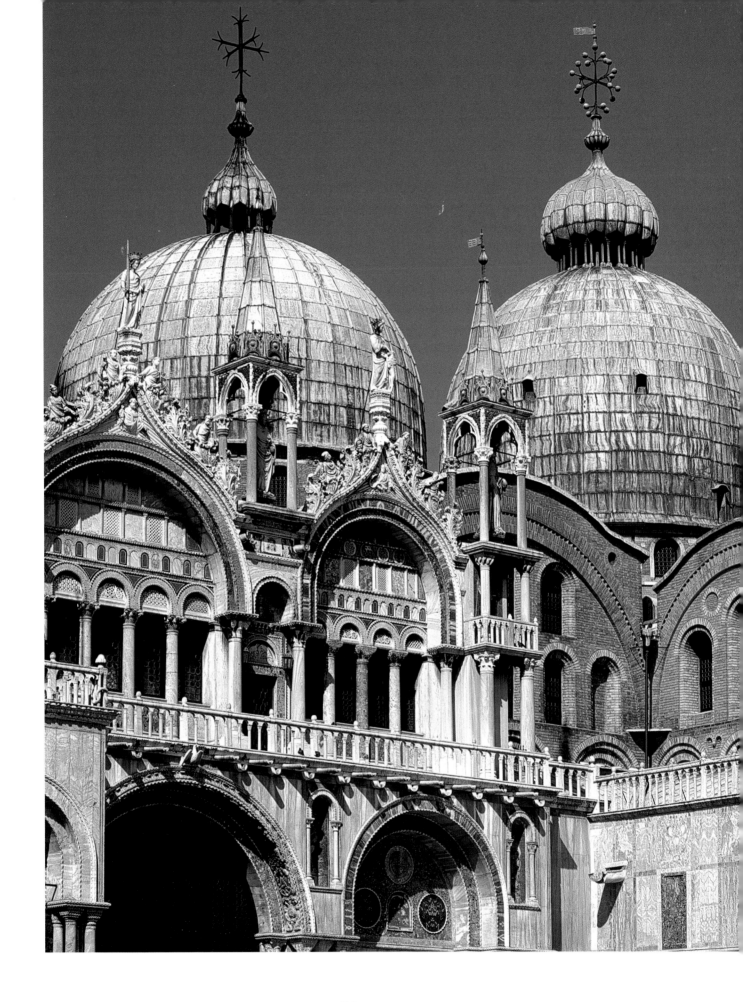

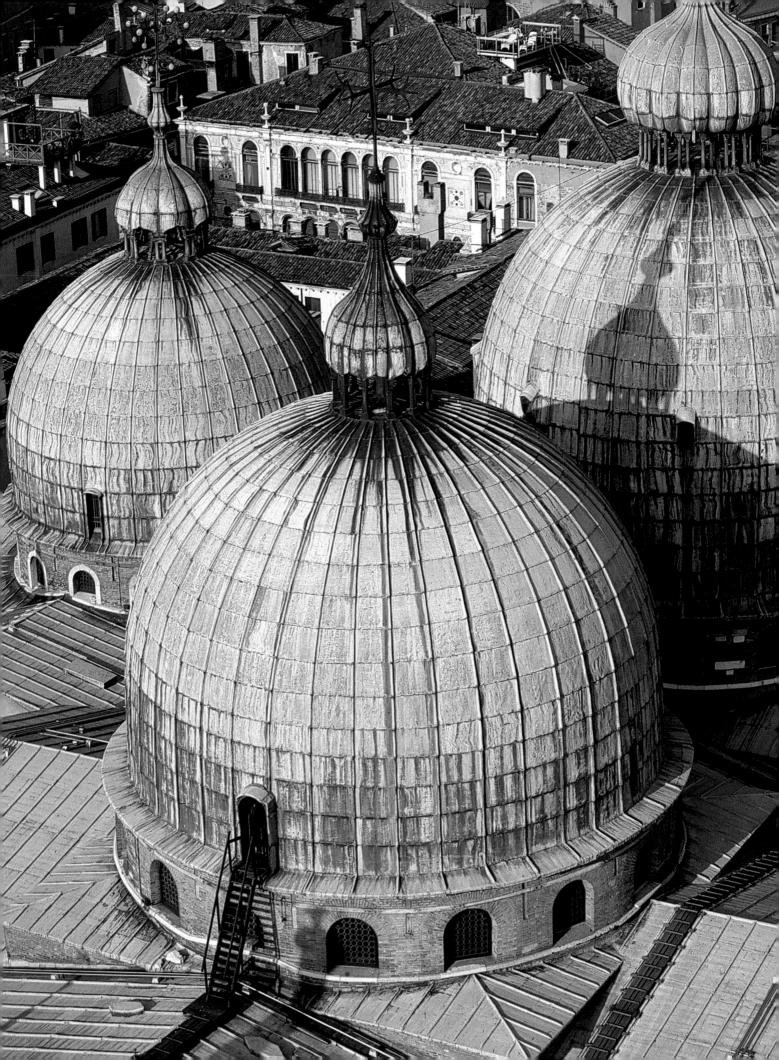

one arrives by ship, like the delegates from Byzantium, or when one arrives at the lagoon, as Goethe did via the Brenta River. Thomas Mann gives a telling description of Gustave Ashenbach's arrival in Venice via the San Marco Canal when, once past the flat lido on the left, he recognizes "that amazing group of incredible structures the Republic set up to meet the awestruck eye of the approaching seafarer: the airy splendour of the palace and the Bridge of Sighs, the columns of lion and saint on the shore, the glory of the projecting flank of the fairy temple, the vista of gateway and clock."

Arriving by sea at the Canale San Marco, one can really see the triumphant Venice of the doges and admire the last great late Roman palace. As with the Palace of Diocletian at Spalato and the two royal palaces at Constantinople, the space around the Doge's Palace houses the residence of the prince of the Venetian Senate. The mausoleum is dedicated to the deified hero-founder of the city – the Apostle Mark, whose body was destined by ancient prophecy to lie in the Venice Lagoon – and there is a large peristyle courtyard. St Mark's Square, which was used as a theatre for civil and religious ceremonies for the entire duration of the Republic, embodies the court of honour used for the cult of the king. In a rather strange way, the entire complex deconstructs the ancient Roman architectural motif without losing its basic unity. At the point where the Piazzetta opens onto the quay, the two columns of St Mark and St Theodore (Todaro) form in the empty space a weightless triple lancet window vaulted by the sky. This motif was elaborated over the centuries through a fusion of styles that were different and yet marvellously coherent. The proto-medieval east side of St Mark resounds in the fifteenth-century clock designed by Mauro Coducci, which clashes with the mature Renaissance Procuratie designed by Sansovino.

St Mark's Basilica is an organic synthesis of Byzantine, Romanesque and late Gothic architectural elements: it was modelled after the plan of the Basilica of the Twelve Apostles in Constantinople, a sixth-century edifice destroyed during the so-called Fourth Crusade, when the city, a major Christian centre, was besieged and pillaged by other Christians. The architectural motif of the elevated domes that emerge from the body of St Mark's is without doubt of Eastern origin. The large and deeply recessed arches open onto Romanesque portals. The monumental pillars are decorated with two registers of small columns that are the exact height of the pillars and that, together with the round arches, divide the lower part of the church façade horizontally into three registers. Above the terrace the Romanesque style embodied by the portals is transformed into flamboyant Gothic and the round arches are crowned

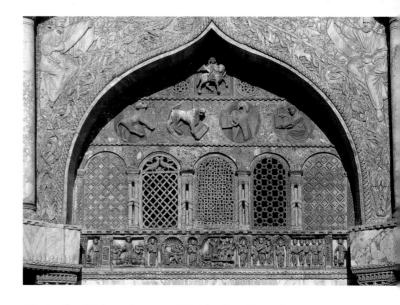

82 In the 13th century the inner surface of the domes in St Mark's were crowned with tall, lead-lined central supporting structures topped by extravagant lanterns with radiating crosses.

83 The lunette with an ogee arch on the Sant'Alipio portal, the first at left on the basilica façade, has 14th-century gilded transennae and paterae with the symbols of the Evangelists.

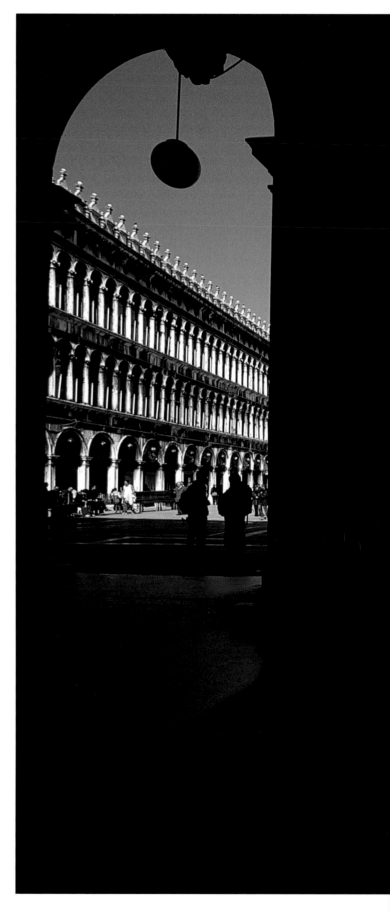

84-85 St Mark's Square highlights the basilica, toward which everything converges in perspective. The lines, curves and arched elements are all a continuous and simplified reference to the geometric elements of the basilica façade and serve as an aesthetic introduction to St Mark's.

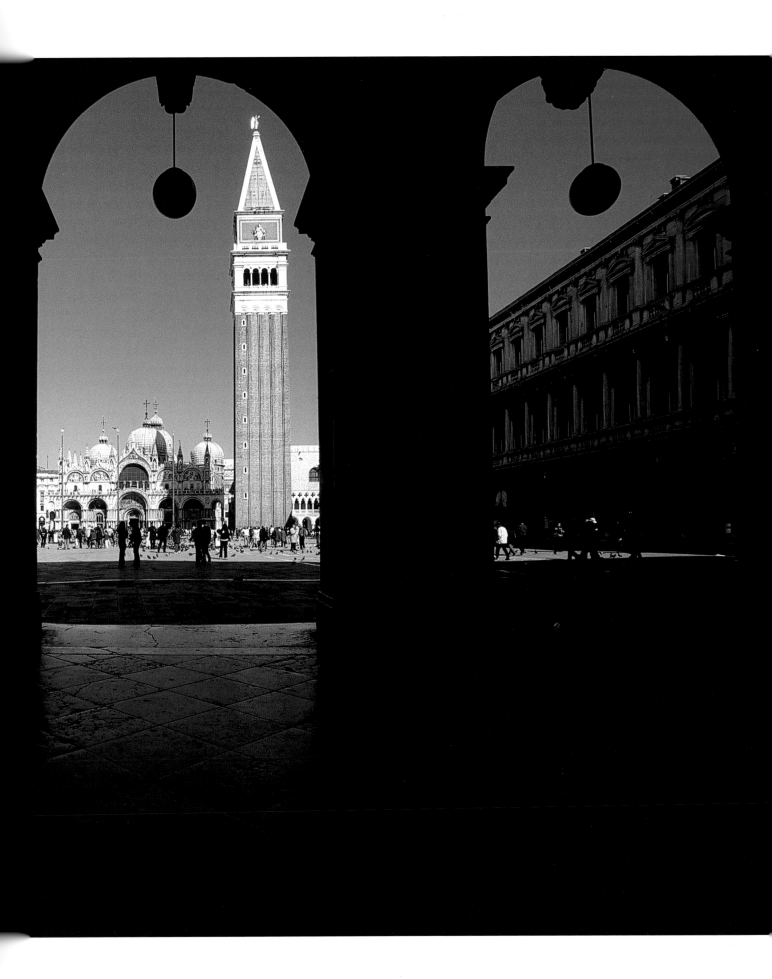

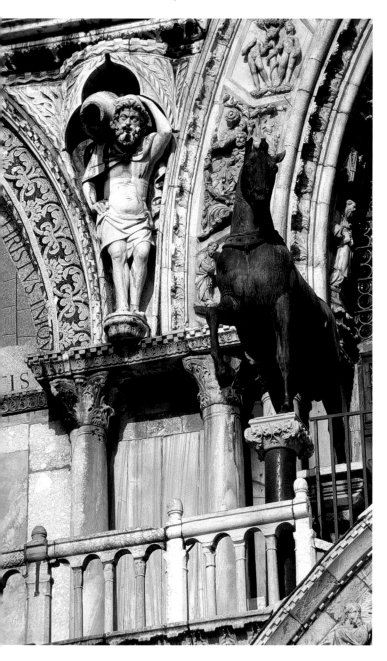

86-87 In 1204, during the Fourth Crusade, Constantinople was conquered and sacked, and the four Greek or Roman gilded bronze horses on the terrace of St Mark's were taken to Venice, where they became one of the magnificent symbols of the city's power. However, these are copies, as the originals are now kept in the Museo di San Marco inside the basilica.

with curved and pointed arches. This Oriental version of the Gothic arch originated in India and its shape is similar to an ancient hieroglyph of the sun rising on the horizon of a clear sky. It reveals the influence of the last Gothic style, which, employed and elaborated in different circles throughout Europe, always calls for a great deal of decoration on the structure. In a harmonious interweaving of various figurative techniques, the entire façade seems to be filled with meanings. On the walls the polychrome inlay decomposes the planes; the mosaics pervade their flat and concave surfaces; the bas-reliefs envelop the column capitals and the arches; and statues occupy the narrow ogival niches and rise up above the spires. This complex and bold composition totally dissolves the masses, annulling all volume.

To enter the interior it is necessary to pass through a narthex that surrounds the basilica on three sides. This narrow atrium, at once external and internal, suggests an obligatory rite of passage between the brightness of St Mark's Square and the sacred space where a refracted light, reverberating in gold, extends to the lucid and fragmented surface of the walls, the magnificent domes, the mysterious ambulatories and the brilliant inlay work. The Venetian Republic was so eager to have its 'palatine chapel' that it entrusted the management to a specially created administrative office of procurators, hence the name Procuratie for the building in which this office was located.

The splendid St Mark's Basilica became the symbol of the entire city, and yet Sergio Bettini, the famous historian and art critic who is an expert on the aesthetics of Venice, asserts that the highest achievement of stylistic consistency in Venetian architecture is the Doge's Palace, the centre of power and mirror of the Venetian cosmos. Classical critics have always repudiated the palace because of

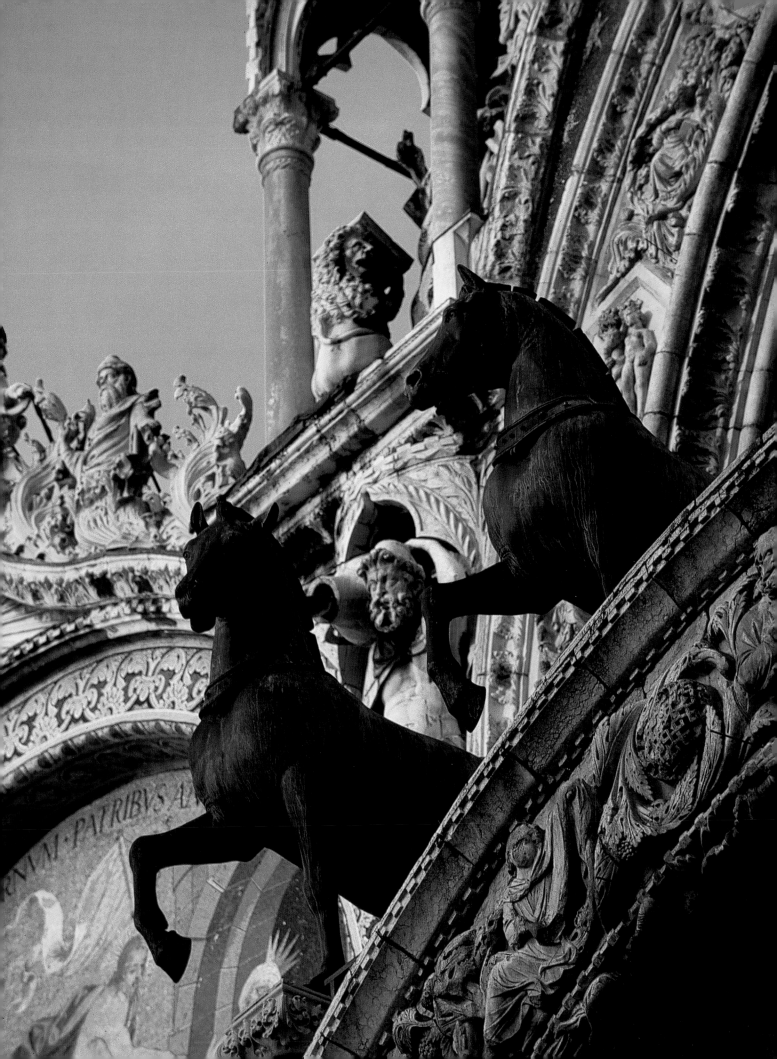

88 On the right-hand side of St Mark's Basilica, on the exterior of the Treasury, is the fine 4th-century porphyry sculpture of the Tetrarchs, whose embrace represents the alliance that was supposed to have supported Diocletian's reformed Roman Empire.

89 Next to the famous Tetrarchs (whom the locals call "the Moors") are some admirable bas-reliefs of griffons and plant motifs. Their provenance is unknown, as is that of the sculpture group, which may have been carved in Syria or Egypt.

the way in which different sections of the building interact with one another. Bettini argues that if we consider the walls of the palace for what they are, that is, splendid planes of colour rather than mass, we will understand that the lower section of the palace, "including the portico and loggia – so filled with thick shadows that have coagulated between the passages of the arches – has greater weight than the large upper surface, which opens out to the light and has only broad, spaced out windows without frames, rather than loggias or multi-lancet windows, precisely so that the light can spread over the façade without being interrupted by shadows and the image of the whole wall can dissolve into a luminous continuity barely veined by the pink on white pattern of the marble: vibrant, light, elevated to the heavens."

In the nineteenth century, after large-scale restoration work, the Museo dell'Opera was founded, boasting an exhibition of models and drawings illustrating the structure of the Doge's Palace and the techniques employed for its construction. Also on display are the original elements – columns, capitals, and arches – that were replaced during the restoration. A visit to the doge's apartments and the Sala del Maggior Consiglio is a truly unique experience. The doges summoned the leading Venetian artists to transform the rooms of the palace into grandiose works of art celebrating the history of the Republic and the illustrious people who had made it great. For the Sala del Maggior Consiglio, the Senate commissioned Tintoretto to paint a huge canvas, the largest in the world, representing Paradise. It is clear that in Venice canvases replaced frescoes in both function and as a medium, and we can well imagine what effect this had on the entire development of Venetian painting.

From the Doge's Palace, via the Ponte dei Sospiri or Bridge of Sighs, you can visit the Piombi, the gloomy Venetian prison

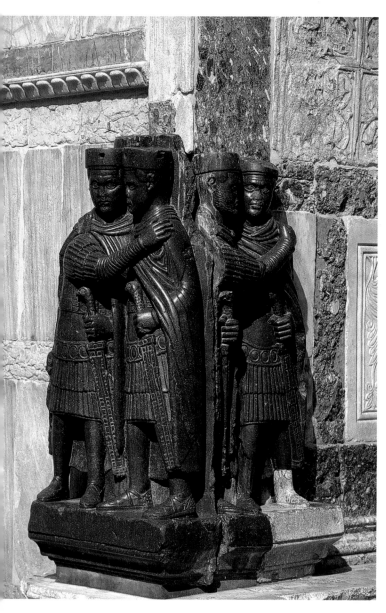

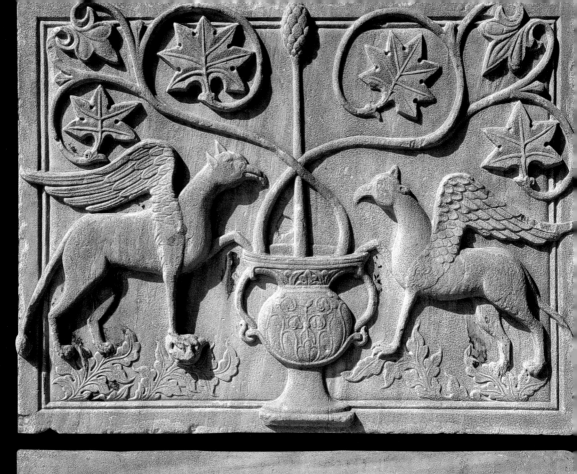

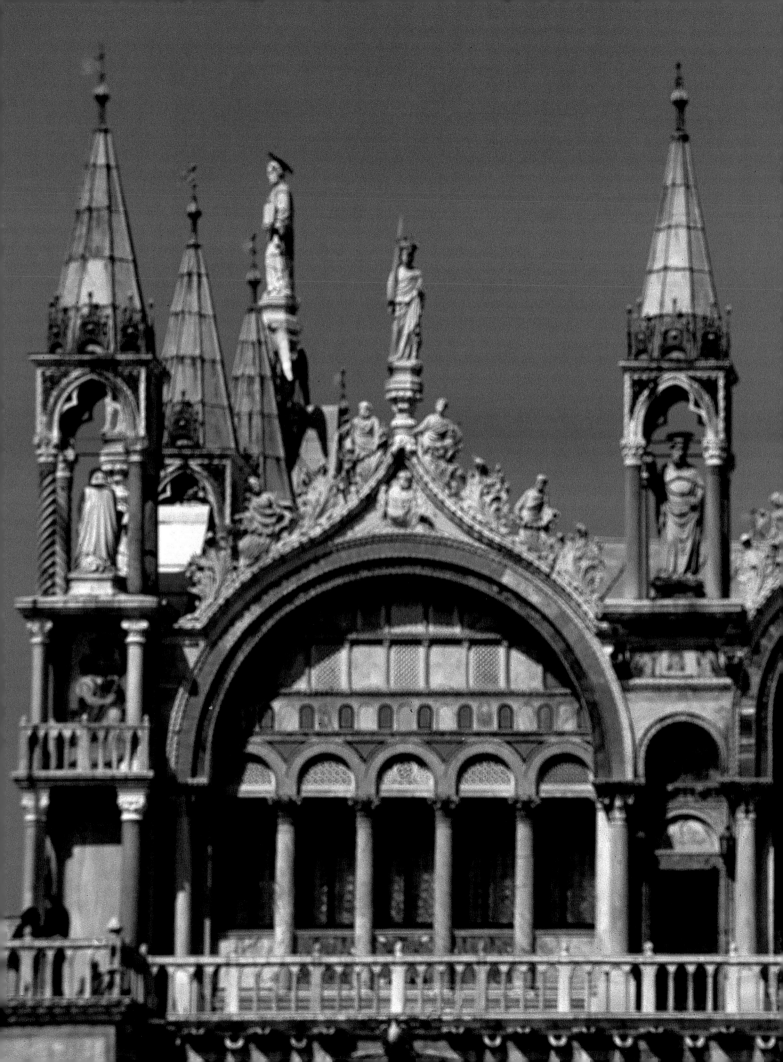

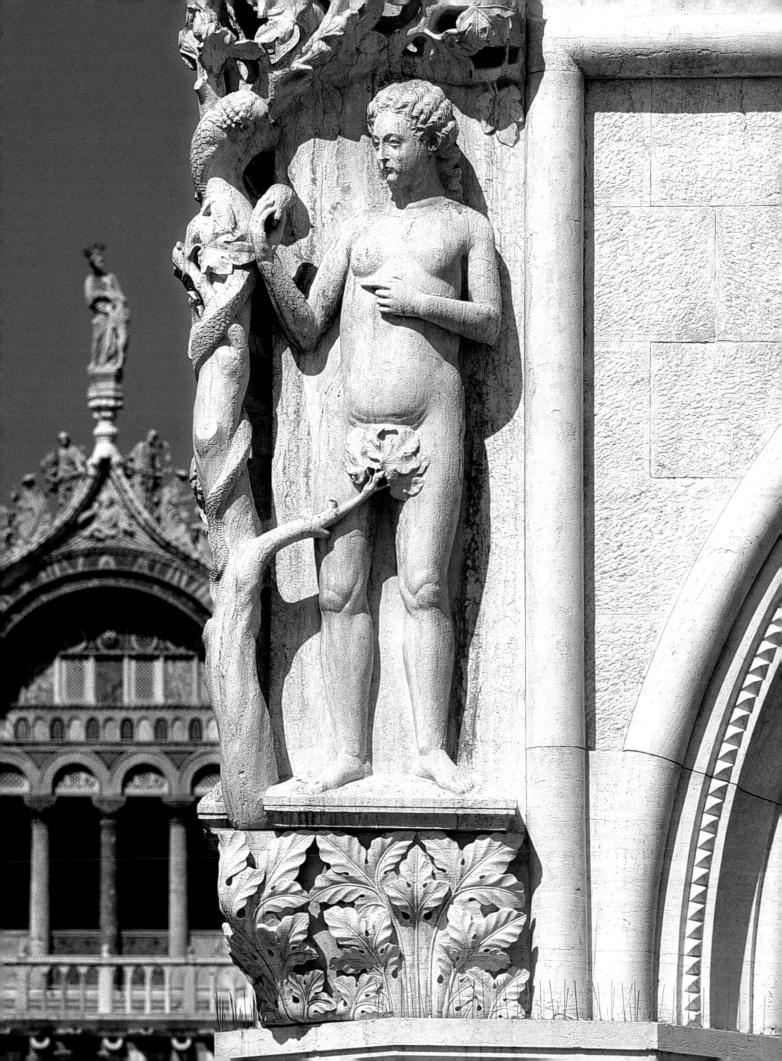

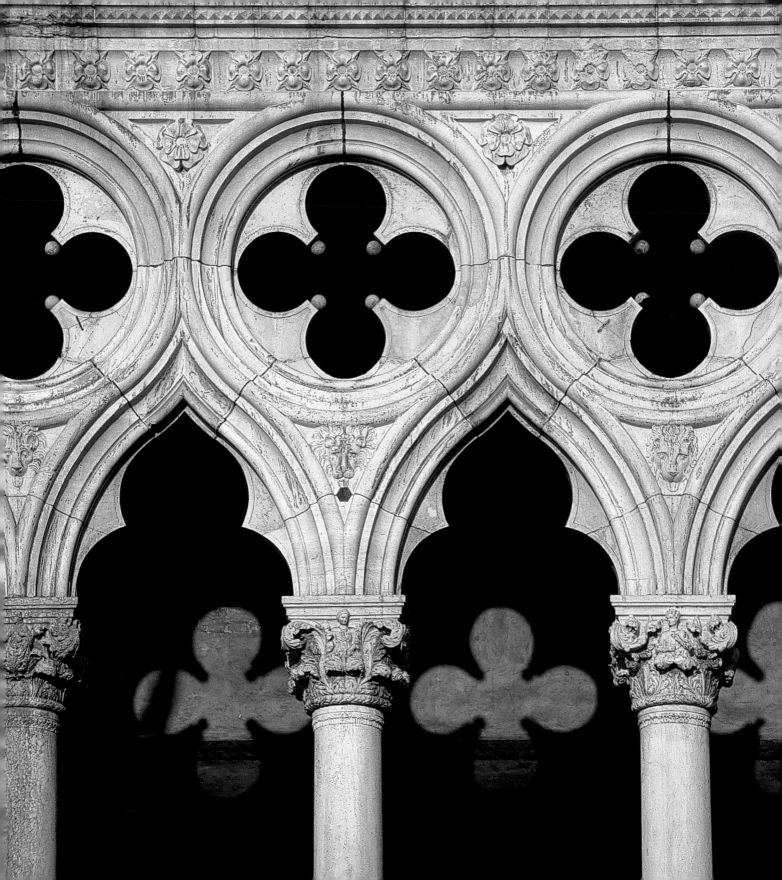

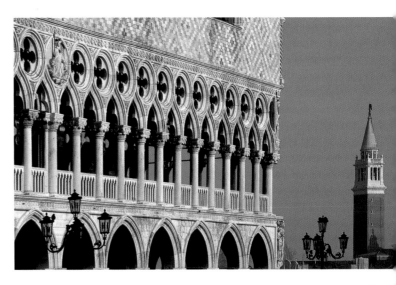

90-91 The Doges' Palace, the residence of the doge and seat of the highest judiciary organs, was built from 1309 to 1422 and is the leading example of Venetian Gothic architecture. Its rich sculpture decoration includes the Original Sin, on the corner between the two façades.

92-93 and 93 above right
The late Gothic style of the Foscara loggia owes much of its effectiveness to the accentuated play of light and shadow.

93 above Part of the decorative program of the Doges' Palace was a statue of the Archangel Michael, "he who at the end of time will subdue evil."

93 below right
The Porta della Carta, the original entrance to the Doges' Palace, is a late Gothic masterpiece that dates from 1438.

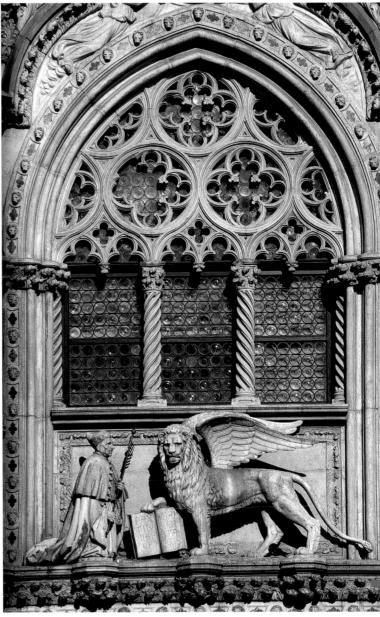

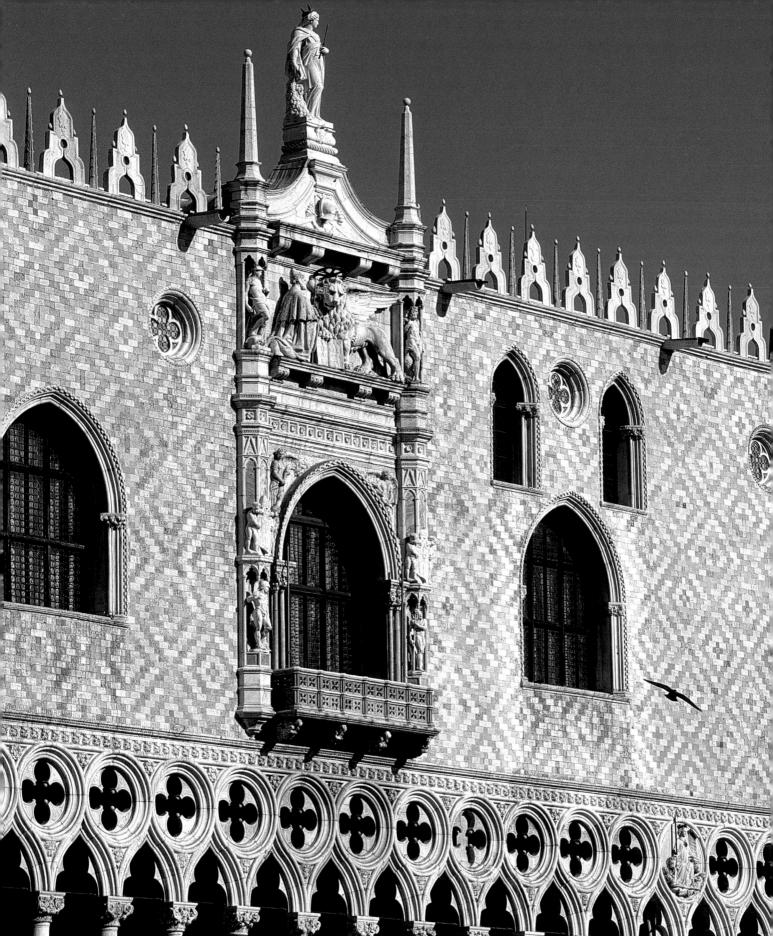

94 The sumptuous balcony of the Sala del Maggior Consiglio was added on the west side of the Doges' Palace in 1536 by Scarpagnino and Sansovino and is a replica of the 15th-century one on the other façade.

95 above View of the loggia with intertwined arches that adds a special touch to the Doges' Palace.

95 below The late Gothic spires of the Arco Foscari stand out in the back of the Renaissance courtyard of the Doges' Palace.

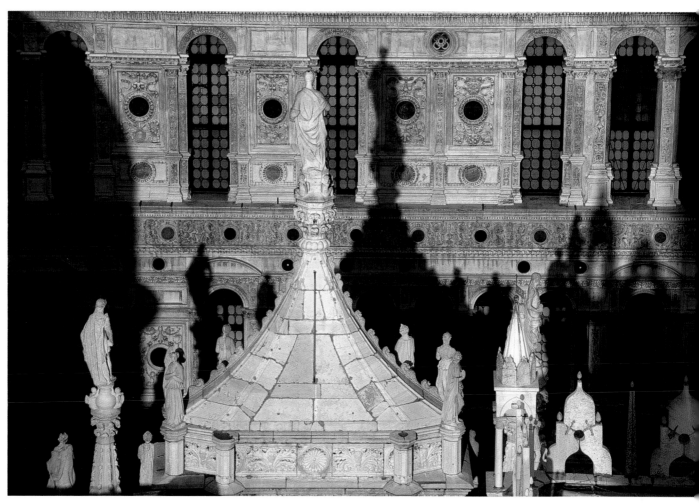

96 The decoration of the Doges' Palace is a mixture of Christian and pagan motifs. For example, side by side with biblical scenes there is a female figure, perhaps representing the tides, that is portrayed with the features of Isis.
A special aspect of the palace is the rich sculptural decoration on the 14th-century capitals, the groups on the corners, and the figures on the Scala dei Giganti staircase designed by Sansovino.

97 The 14th-century sculpture group portraying the drunkenness of Noah belongs to on the oldest part of the Doges' Palace, which faces the basin. In the background is the famous Bridge of Sighs, built in 1600 to connect the Doges' palace and the state prisons, the notorious Piombi. This intriguing name was given to the bridge because the prisoners passed over it to be interrogated by the inquisitors.

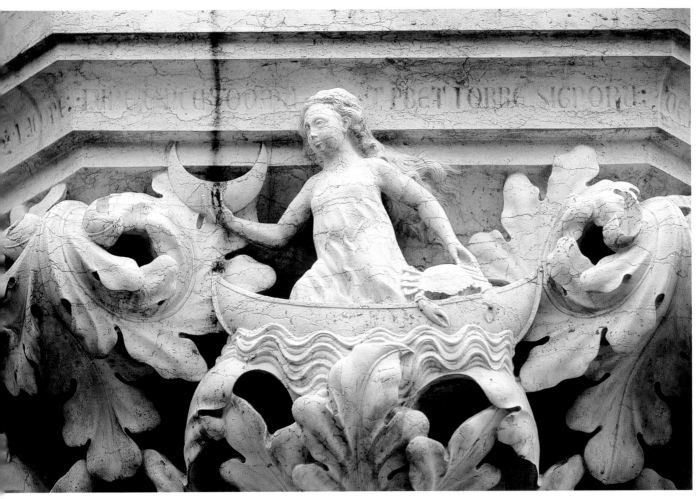

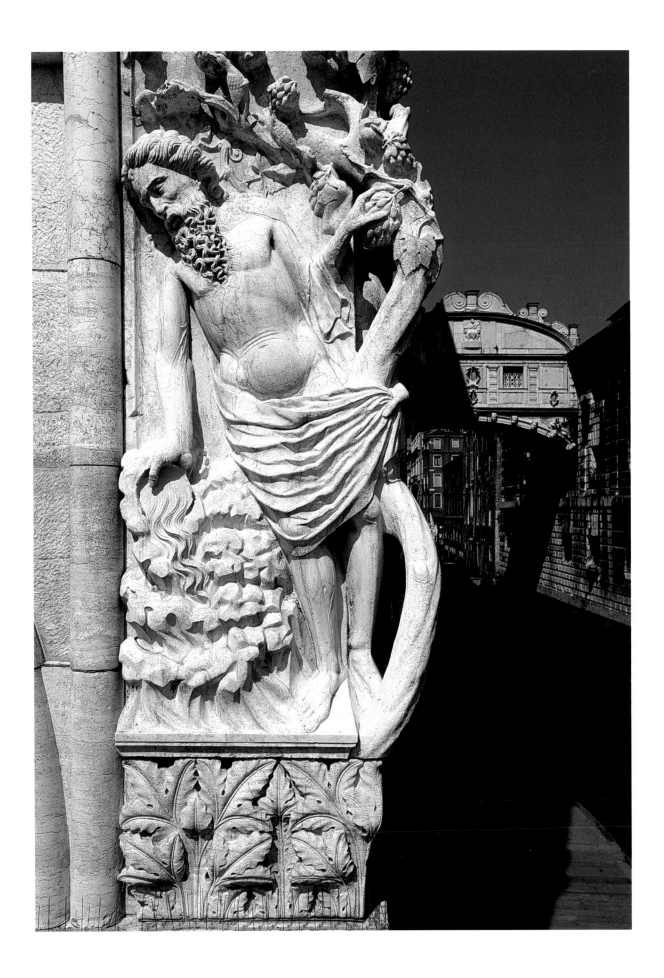

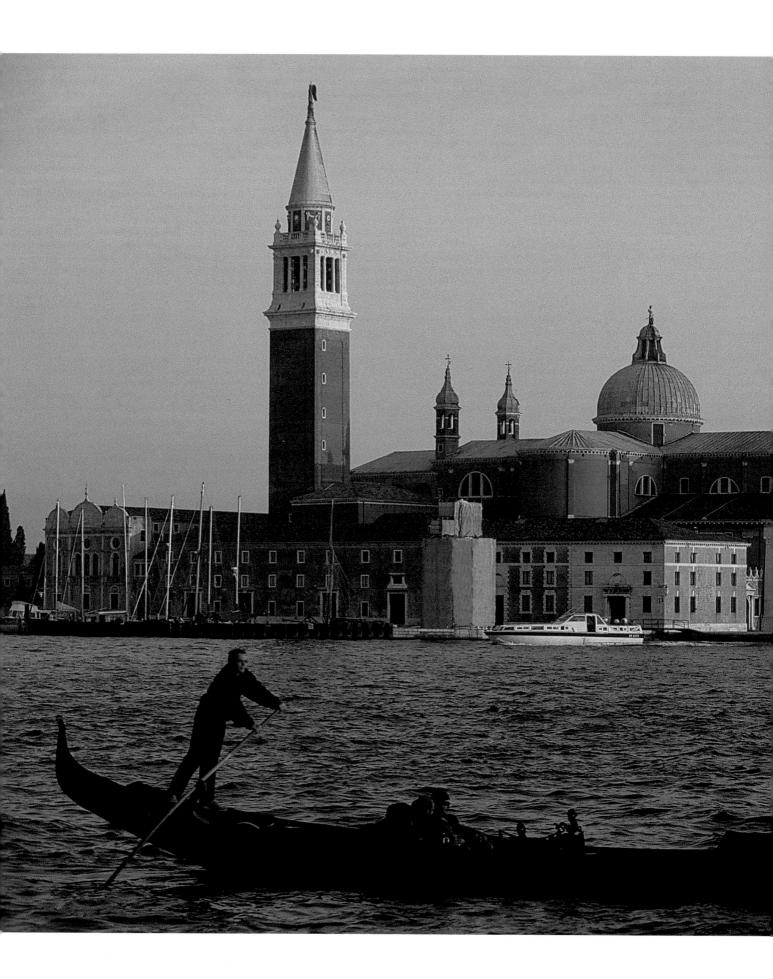

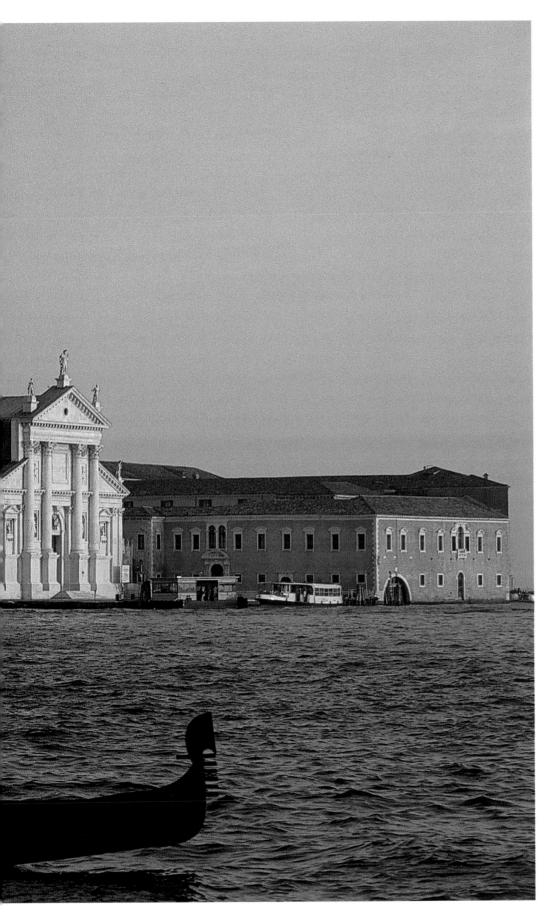

98-99 The early morning light sweeps over San Giorgio Maggiore, the large church Palladio built on the island of the same name in 1560-80.

99 The Column of St Mark stands out against San Giorgio Maggiore in the background. The bronze statue on top is presumably a Chinese chimera, to which the wings were added to make it look like the Lion of St Mark, the symbol of the city.

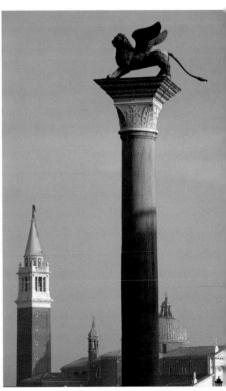

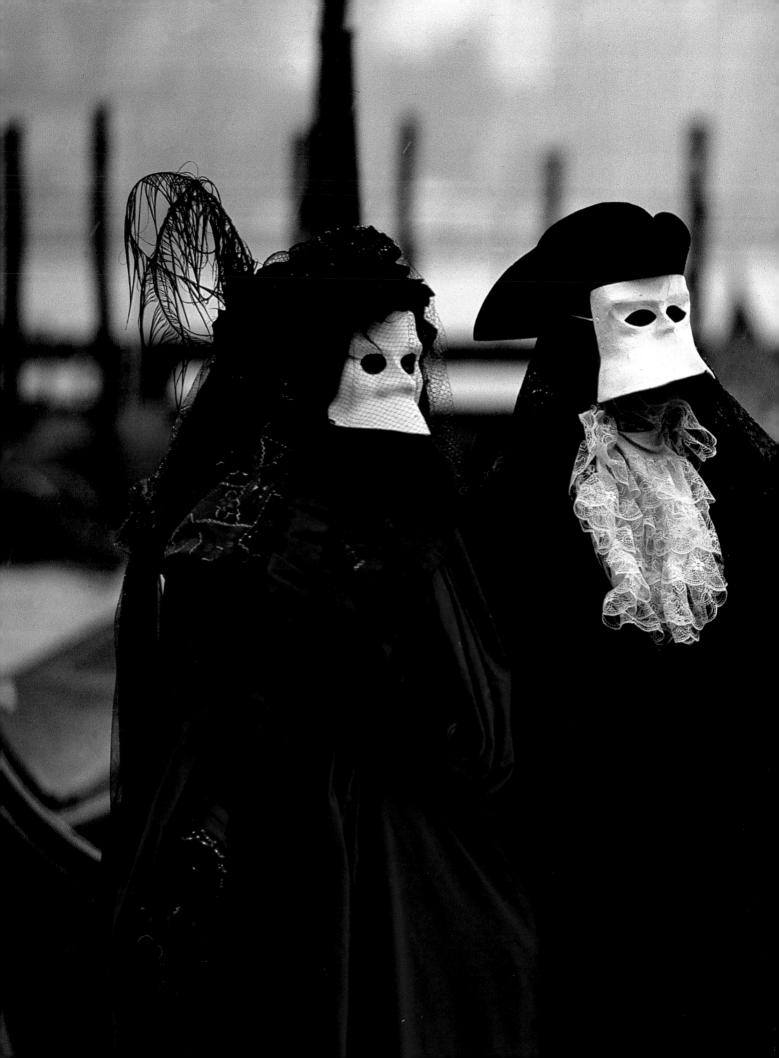

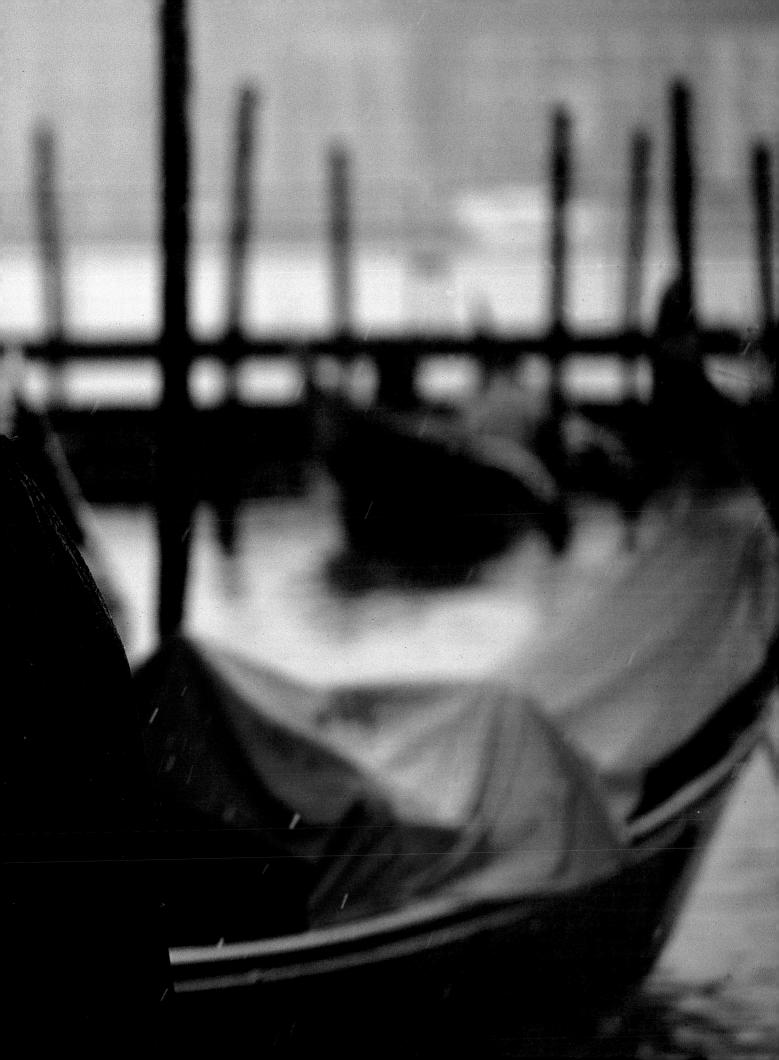

that had many illustrious 'guests', including Giacomo Casanova, whose interesting experience there is worth relating. On 26 July 1755 the chief of the Venetian police, Mattio Varutti, raided his house on the Fondamenta Nove, enjoined him to hand over all his writings and books, and ordered him to get dressed and follow him. Casanova was accused of many things: he was suspected of corruption and licentiousness, of being a card shark, an atheist, pimp, alchemist, sorcerer and mason – all accusations that the Inquisition tried to prove. However, one gets the impression that the real reason for his arrest was that the Venetian gentleman had trodden on the corns of too many high-ranking people. Casanova's imprisonment lasted for 15 months, most

of which he spent conceiving his spectacular escape, which was successful thanks to the gullibility of Lorenzo Bassadona, his gaoler. Casanova climbed up to the roof from his cell and then went down into an attic. While he was furtively passing through the rooms of the Doge's Palace, he was spotted by Bassadona, who supposedly thought he was a Venetian politician who had inadvertently been locked in the palace and therefore let him out. Once out of the Porta della Carta, Casanova got into a gondola and fled from his home town.

The Porta della Carta, situated between the Doge's Palace and St Mark's, connects the Piazzetta and the Cortile Maggiore. On the last Sunday of Carnival, this large inner courtyard of the palace was the

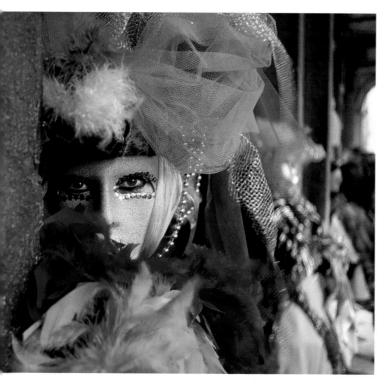

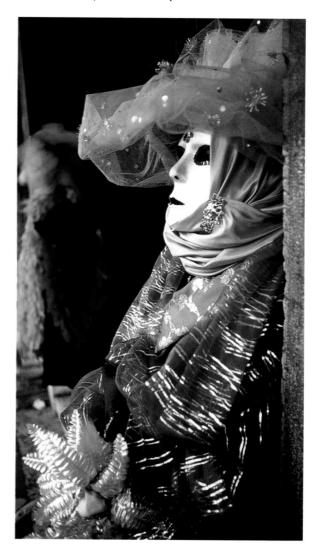

100-101 The most common disguise for Carnival is the larva, *which includes an oilcloth mask that was originally black and then became white, a black veil that covers the ears and neck, and then the tricorne or cocked hat and tabard, which are also black.*

102-103 During the Carnival period Venice forgets it is an art city and becomes a jam-packed post-modern theater.

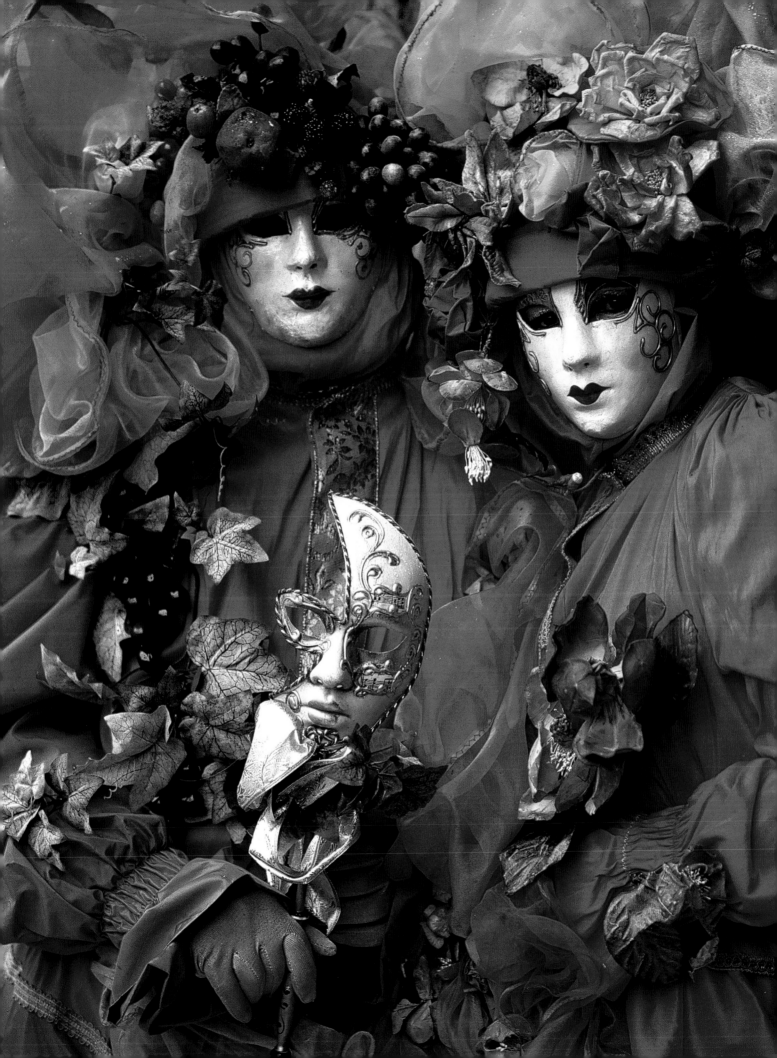

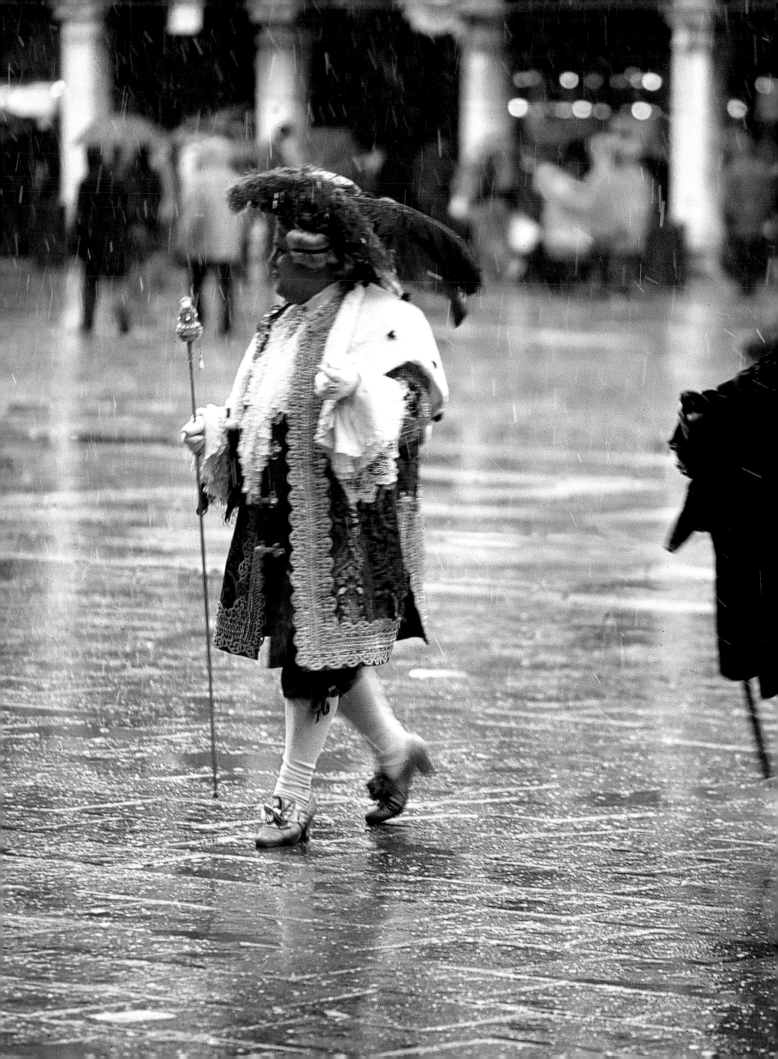

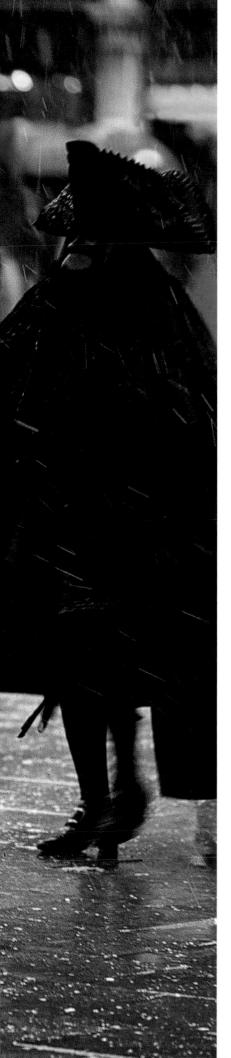

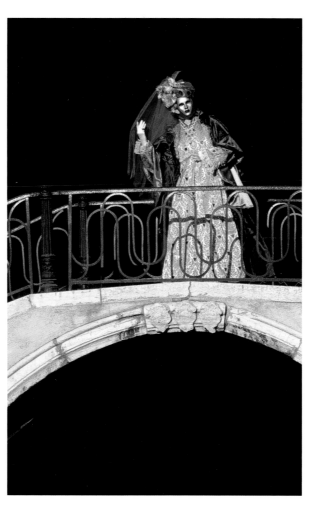

104-105 The Carnival in Venice is certainly one of the most famous in the world despite the fact that it was re-established rather recently. The reason for this success is due to the exuberance of the participants and the lavish costumes, but above all to the extraordinary setting of the city, whose fascination is by no means lessened by an unexpected and rare snowfall. Carnival is the representation of the suspension of all official rules and regulations, when the mask serves to overturn the established social conventions.

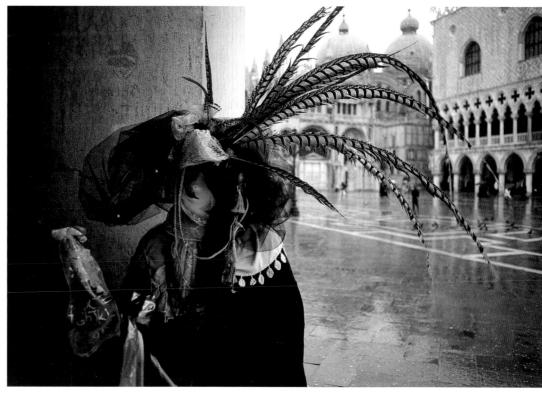

venue for a spectacular and cruel bullfight, which it seems entertained the dogaressa's handmaidens most of all. The *becheri*, or butchers, mounted an arena in the court with a grandstand and loggias built under the arches, while the best seats in the upper galleries of the palace were rented for one ducat. At the end of the bullfight, a butcher took a huge sword in his two hands and with one blow cut off the heads of some of the bulls.

There were many rituals and ceremonies held during Carnival that originally were of pagan derivation but had been transformed into celebrations of the power and grandeur of the Most Serene Republic. The Macchina dei Fuochi (Fire Machine) was identified with war, the Forze d'Ercole (Powers of Hercules) with the skill of the Venetians in taking the walls of Aquileia by storm, the Moresca Dance

106-107 The various costumes in the present-day Carnival include all the various 18th-century masks, which are reinterpreted in different shapes, colors and sizes. Be they sumptuous or minimalist, the mass-produced masks reflect our post-modern identity, with all its contradictions.

stood for battle, the Taglio della Testa (Decapitation of the Bull) was identified with justice and the Volo dell'Angelo (Angel's Flight) with peace. Nowadays the only remaining ancient ceremony is the Angel's Flight, which inaugurates the start of the Carnival proper.

The Venice Carnival, which attracts thousands of people every year from all parts of the world, has retained its unique fascination. During these festivities Venice doffs its veneer as an art city and becomes a crowded postmodern theatre. In the past, the Carnival went on for a lengthy period, with a 'preview' in early October on the occasion of the opening of the theatre season. However, the Carnival proper began on St Stephen's Day (the day after Christmas), when the government allowed citizens to wear masks. The festivities culminated on the Thursday

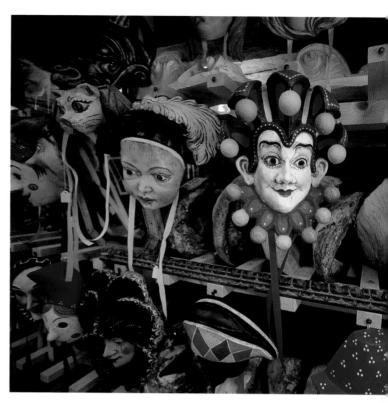

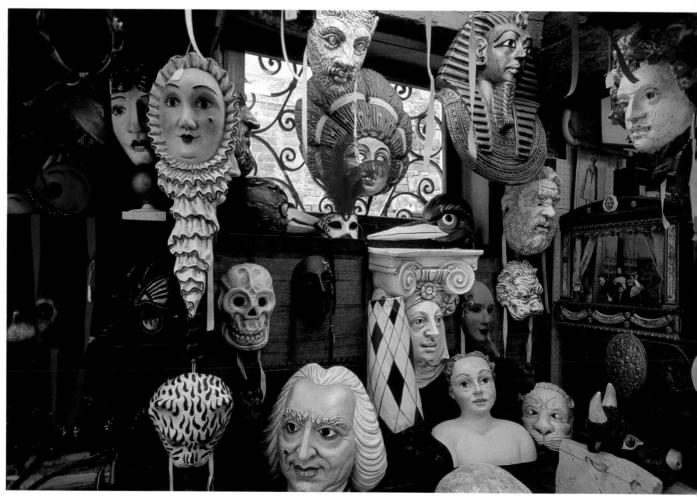

before Lent and ended on the day before Ash Wednesday with a grand banquet to mark the farewell to meat, which was prohibited for the entire Lent period.

From the mid-fifteenth century to the end of the sixteenth century the organization of the Carnival festivities was entrusted to the Compagnie della Calza, associations of young patricians whose emblem consisted of stockings (*calze*) divided into quarters of different colours. In Venice, as in every part of the world, Carnival is basically the representation of the suspension of all rules and established order, in which the mask served to blur the usual social codes and distinctions. During the Carnival period, patricians and commoners mingled together with dancers, charlatans, balsam and ointment vendors, strolling players and snake charmers. The most usual costume in

eighteenth-century Venice consisted of the *larva* (a mask made of waxed cloth that was originally black and then became white), a black veil that covered the ears and neck, a cocked hat, and a tabard. Nowadays, the eighteenth-century motif is reinterpreted in various shapes, sizes and colours. Either gaudy or 'minimalist,' and mass-produced, the Carnival masks embody the human comedy of the postmodern era, with all its complexity, alienation and disjunction. The present-day Carnival was reborn in 1979 thanks to some local associations that revived the tradition that had been abandoned for years, an initiative that was supported by the enthusiasm and active participation of the citizens. Since that time, the local government, and subsequently the Carnival Society Committee, has been organizing and promoting the various

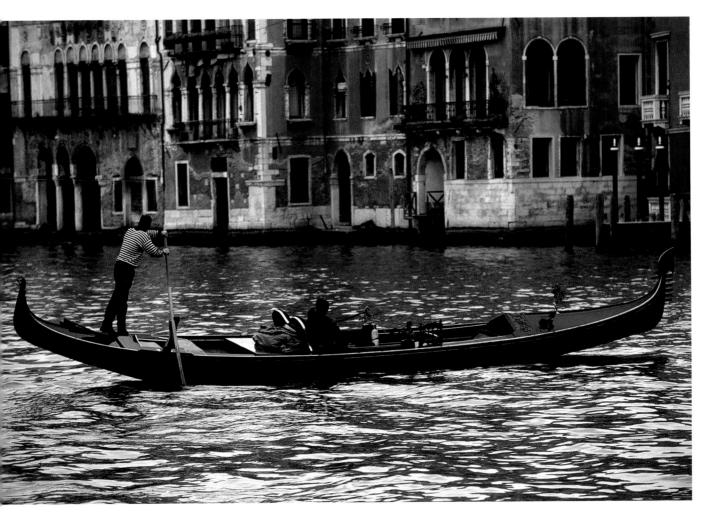

events, such as theatre and dance, exhibitions, concerts, fashion shows and costume parties that are held in Venice and on the mainland in the ten days before Ash Wednesday. The hub of the festivities is St Mark's Square, where the Carnival is officially inaugurated when the Colombina – a young Venetian girl – flies over the crowd (naturally, hanging from a cable). During this period it is virtually impossible to visit the city, and the only opportunity to do so – if one can afford it – is to take the last available gondola.

Before accompanying the reader onto the surface of the water, where voices seem to become immaterial and dispersed on the waves, I would like once again to call on the gloomy, visionary genius of Thomas Mann, who in *Death in Venice* asks: "Is there anyone but must repress a secret thrill, on arriving in Venice for the first

108-109 The Grand Canal meanders through the heart of Venice like a placid river.

109 above Always filled with gondolas,

water buses, barges and motorboats, the Grand Canal is flanked by splendid buildings such as the Palazzo Bembo, whose façade has ogee windows with fine tracery.

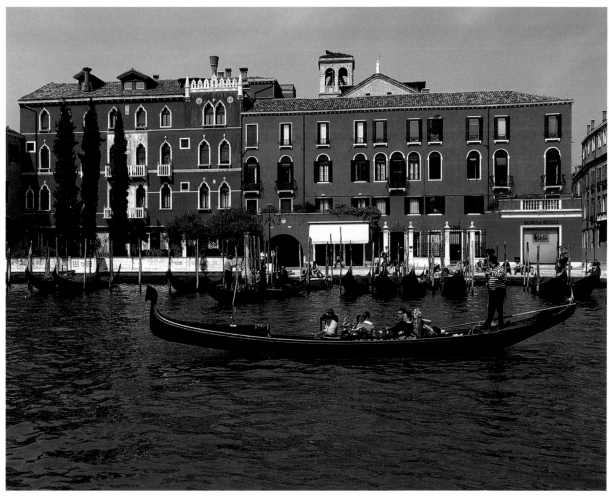

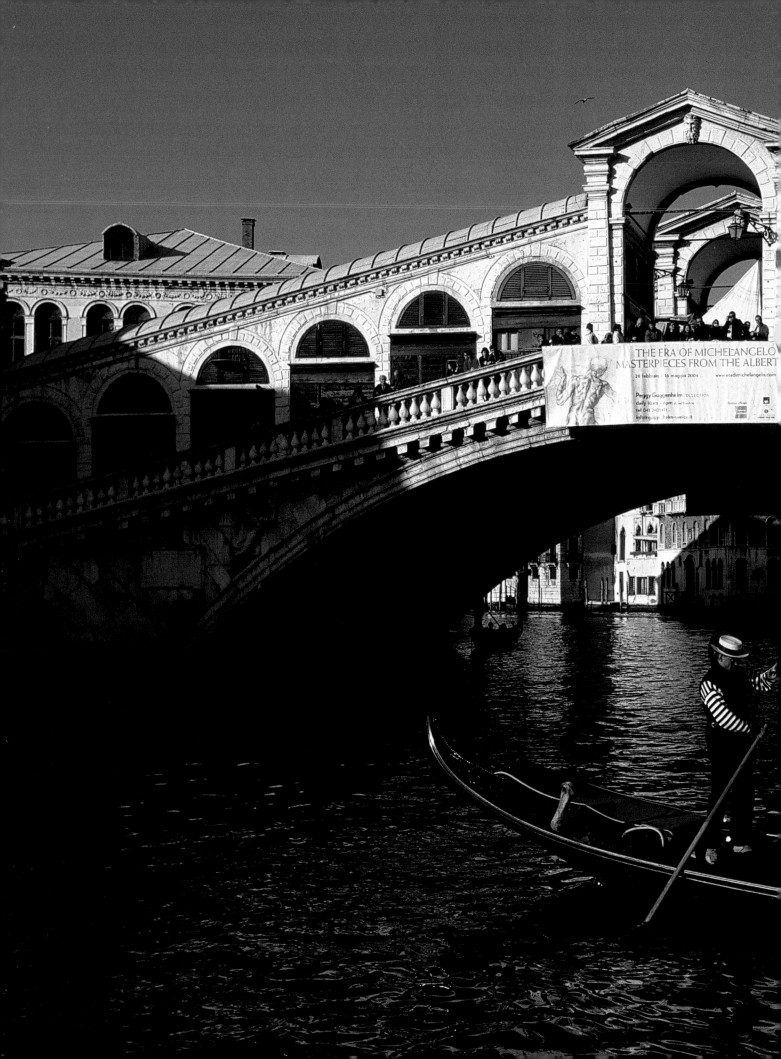

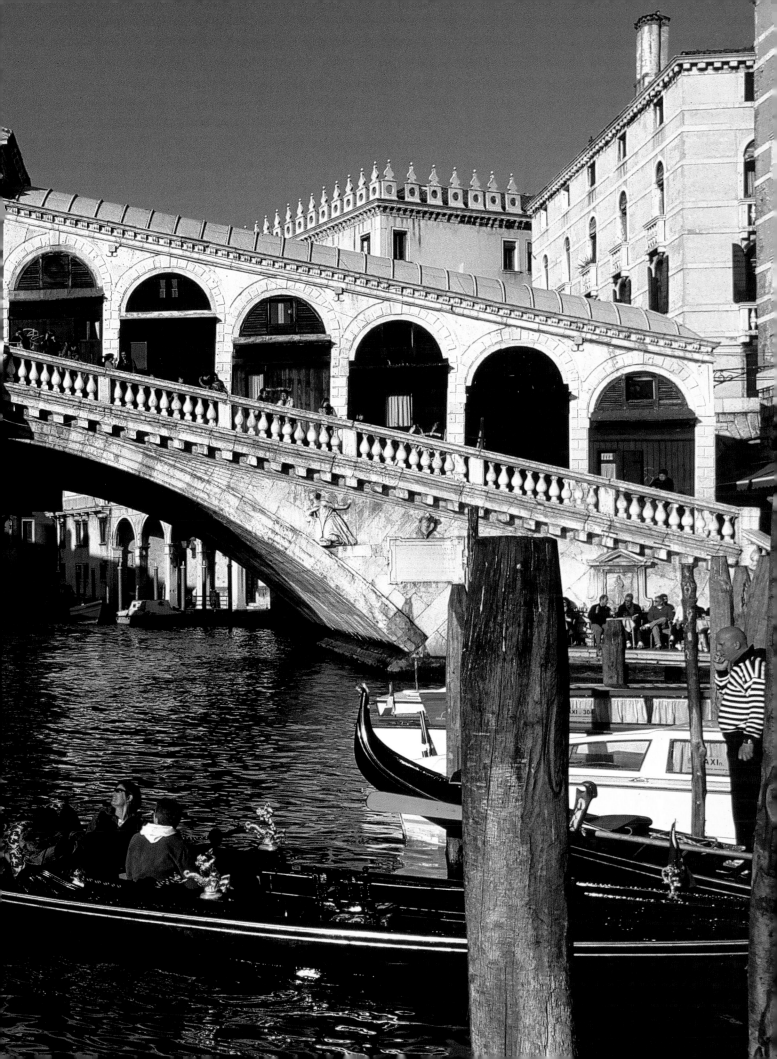

time – or returning thither after a long absence – and stepping into a Venetian gondola? That singular conveyance, come down unchanged from ballad times, black as nothing else on earth except a coffin – what pictures it calls up of lawless, silent adventures in the plashing night; or even more, what visions of death itself, the bier and solemn rites and last soundless voyage! And has anyone remarked that the seat in such a bark, the armchair lacquered in coffin-black and dully black-upholstered, is the softest, most luxurious, most relaxing seat in the world?"

But let us leave behind us the worries, restlessness and funereal evocations of Thomas Mann and, like Goethe, let us imagine we are in the midst of doges, the lords of the lagoon appearing before us, or industrious merchants who have just returned from the Silk Road after concluding profitable trade transactions.

From the Canale di San Marco you will

110-111 The Rialto Bridge, now a popular tourist attraction, was once the heart of the city's commercial activity. It was built in 1588 by Antonio Da Ponte, whose project was considered avant-garde at the time.

112 A gondolier on the Grand Canal polishes the iron prow of his gondola.

113 The Grand Canal is the theater of all the everyday activities that result from centuries of adaptation to the aquatic environment.

note that the natural access to Venice is the Grand Canal: going down this water thoroughfare to the slow rhythm of its wide bends, you will see the splendid palaces built for the most illustrious aristocratic families, the Contarini, Loredan, Giustinian and Foscari. These noble edifices evoke past pomp and splendour and a fantasy world populated by noblewomen and powerful statesmen, sophisticated bishops and ambassadors. However, our excitement reaches its peak when we arrive in front of the Ca' d'Oro. The façades of this palace, the six-lancet windows with their precious interwoven ogee arches, tracery and quatrefoil openings, reveal the rise of the Gothic style, which supplanted the simpler Byzantine forms. We then understand that the work of the Venetian architects and builders consisted of erecting, in a space conceived as pure light, surfaces that were often like large screens on which the sunlight could act. The skilful architect works on the surfaces so that the light absorbs the material and transforms it into a new being consisting of ether that "flames with light", as Alexander Pope said, and that is doubled in intensity by the mirror of the canal that balances its weight and substance.

Venice is different for those who arrive by train, emerge from the railway station and immediately cross over the Grand Canal. The Scalzi Bridge rises high over the canal and the placid series of buildings, and allows visitors to reach the heart of the Santa Croce district via Calle Longa and Fondamenta dei Garzotti, where they will see the Campo di San Giacomo dell'Orio, a charming square bounded by sides of different lengths into which there open various streets and alleys. Facing the canal is the austere Romanesque church of San Giacomo, the interior of which is decorated with fine sixteenth-century canvases and has a splendid wood truss, while on the exterior, facing the square, there is a series

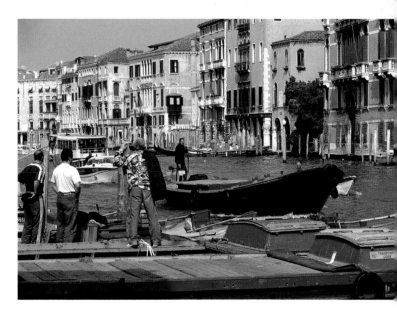

113

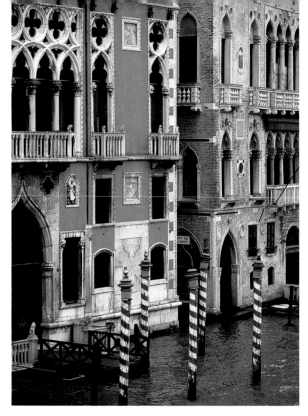

114 Time has left deep scars on the magnificent palazzi along the Grand Canal, and yet it is still "the most beautiful street in the world," as the ambassador of the French king Charles VIII said in 1495.

115 above The Ca' d'Oro, the jewel of the Venetian Gothic style, lies along the Grand Canal.

115 below Soaring over the theatrical setting of the Grand Canal is the impressive Baroque church of Santa Maria della Salute.

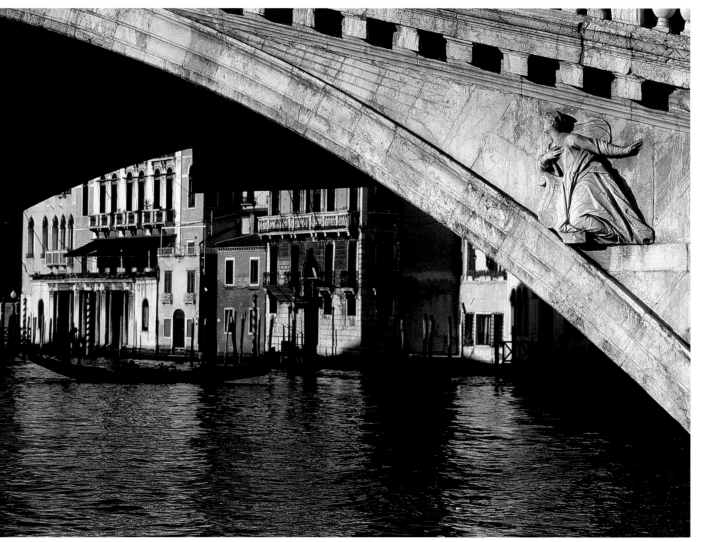

of dissimilar chapels that were added to the church over the centuries.

We are now in the most intimate section of Venice, among especially secluded alleys that give out a feeling of having been lovingly protected. Here the city seems to abandon its patrician guise and takes on the more humble aspect of a nursemaid. Proceeding to Calle Tento towards Campo San Polo, you will come upon a maze of junctions, detours, dilapidated and unstable walls, diverse columns with varied capitals, and seemingly tottering bridges. Here and there you may hear the chirping of birds and you will sense that there are secret gardens nearby. On these streets you will come across Venetians engaged in entering or leaving shops or pushing long, narrow carts; many of them are bricklayers. In fact, it is strange to see, along the canal next to a decrepit building, cement sitting on a boat on the water and, on the next boat, a wheelbarrow filled with sand.

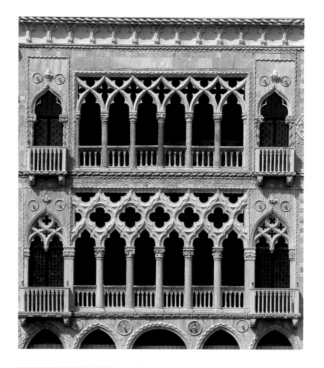

Along the walls of the *palazzi* and other buildings our attention is drawn to the many curious place names that refer to various trades. The artisans, from the milkman to the goldsmith, belonged to the ancient Arti (guilds) headed by the Scuole or confraternities. These Scuole were corporations founded on the basis of common economic interests and religious ideals; and they protected their members by establishing the lengths and conditions of apprenticeships and by regulating their rights and obligations. Furthermore, they also helped people who were ill and provided charity for the poor. To become a member of a guild one had to be skilled in one's trade and to lead a virtuous life. Every activity was under the protection of its own patron saint, whose name day was celebrated in a very solemn manner. From the Mariegola dei Botteri, which was a kind of statute of the Scuola dei Botteri (barrel-makers' guild), we know that the minimum age for an apprentice was

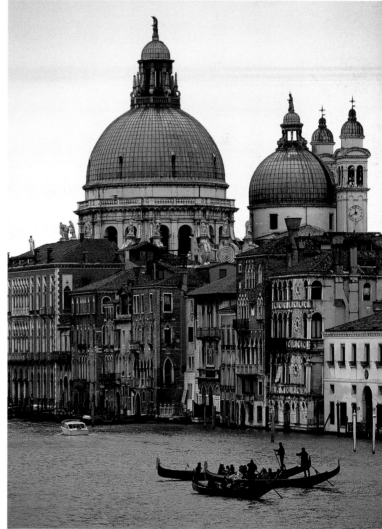

seven, since this profession was not considered particularly fatiguing. In every guild one became a fully-fledged worker after five or seven years of apprenticeship; later, after passing the guild test, one became a master craftsman and could open one's own workshop. Considering the widespread danger of fires, craftsmen could not work at night and had to keep firewood near the fireplaces. When he had finished making a product, the artisan would put his own 'trademark' on it.

The statute of the Arte dei Calagheri, the shoemakers' and cobblers' guild, whose patron saint was St Anianus, dates from 1278. Above the entrance of their Scuola is an unusual marble relief by Pietro Lombardo representing St Mark healing the cobbler Anianus of Alexandria. To this day, in Calle delle Botteghe at San Samuele, you can see a fourteenth-century relief in Istrian stone depicting footwear, and this relief is again to be found at the corner of the same street where it meets the Salizada San Samuele. At San Polo, near the Rialto, the Scuola dei Pestrinieri, or milkmen's guild, had its headquarters in San Matteo Church. This singular name comes from *pestrin*, an ancient mill in which cows made the millstone turn. Besides milk, the *pestrinieri* sold cream, ricotta cheese and butter. Their products were sold every day including holidays throughout the city by twelve workmen who were chosen by lots. Moreover, women who had a cow and paid a tax to the guild or brotherhood were allowed to sell their wares on a door-to-door basis. The goldsmiths' trade, on the other hand, was divided into sectors, including so-called imitation jewellers, namely those who dealt in costume jewellery to use a modern term. In 1331 the Maggior Consiglio decreed that goldsmiths could have shops only in the Rialto area, and even after the repeal of this regulation most of them kept their shops on the Rialto Bridge, as we can see today. Many other Scuole or corporations joined them,

including the Scuola dei Pistori (bakers) and those of the *mureri* (builders) and *tagiapiera* (stonemasons).

While the minor guilds concentrated mostly on teaching a specific trade, the Scuole Grandi were devoted mainly to charitable works. In the San Polo district we have the Scuola Grande di San Rocco, on the façade of which early Renaissance elements blend harmoniously with harbingers of the Baroque style, while the interior boasts many canvases by Tintoretto and a few by Titian. Opposite this, towering over Campo San Rocco is the gigantic Santa Maria Gloriosa dei Frari church. The monumental soaring lines of this superb example of Gothic architecture surpass all the other Venetian basilicas, while the simplicity of its surfaces and materials highlights the harmonious equilibrium of its forms. The lovely brick campanile, which is enhanced by the

116-117 While strolling through the streets and squares of Venice you will continuously come upon curious establishments and shops; be it a trattoria *with an elaborate sign, a refined antique shop, or a store with bric-a-brac, there is always something interesting to see in the shop windows.*

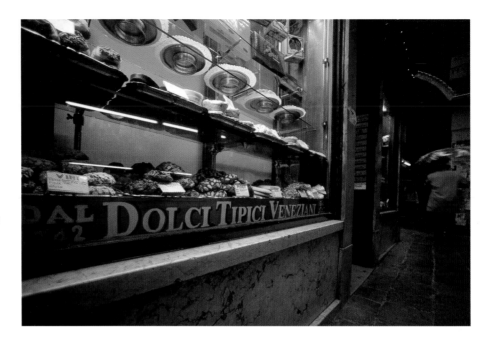

118 Venice is also famous for its exquisite traditional cuisine and elegant handicrafts. Here we see the shop windows of an old pastry shop and a workshop specialized in shiny brass objects.

added touch of fine Istrian stone, is a carryover from the Romanesque style with its combination of two colours. This complex was beautified over the centuries with various constructions, including the Ca' Grande dei Frari and two cloisters. Today this basilica houses precious paintings, and concerts and choir performances are often held in the nave.

From the Frari Church, you enter the Dorsoduro district by crossing over the canal that skirts Ca' Foscari, the local university that has been under restoration for years. Here, the city is more exposed to sunlight; the streets often lead to squares, both large and small, and little wood and brick bridges diverge slightly and weave ever-changing spaces on the water. The large Santa Margherita Square is the hub of nightlife in this neighbourhood, which is the liveliest in town, frequented by young people and university students who gather in the many pubs and trendy nightspots.

Dorsoduro boasts the Accademia delle Belle Arti, the Fine Arts Academy that the Venetian Senate founded in 1750. In its rooms, which were once part of Santa Maria della Carita, it has over the years acquired many masterpieces from the churches and convents of the Veneto region. Giannantonio Selva, professor of architecture and well-known exponent of Neoclassicism, adapted the complex of buildings to their new role by creating a bold and unusual fusion of Gothic, Palladian and Neoclassical structures. This museum houses works by Paolo Veneziano, Niccolò di Pietro, Antonio Vivarini, Carpaccio, Bellini, Luciani, Giorgione, Pisanello, Mantegna, Filippo Lippi, Rondinelli (strangely enough), Cosmé Tura, Tintoretto, Veronese and Titian, as well as many great seventeenth- and eighteenth-century artists of the Venetian school.

All the churches in Venice have paintings and art treasures and many *palazzi* can boast invaluable collections of

119 above In the Campo della Pescheria market you will see the jovial fish vendors as well as all the different people who populate the city: from the tourists who cannot help taking photos of the fish, to the rich Venetian ladies holding their designer handbags tightly against their bodies.

119 below The typical atmosphere of the many cafés around St Mark's Square is quite different.

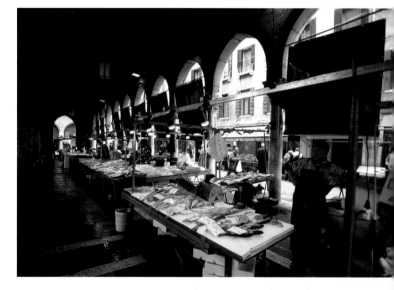

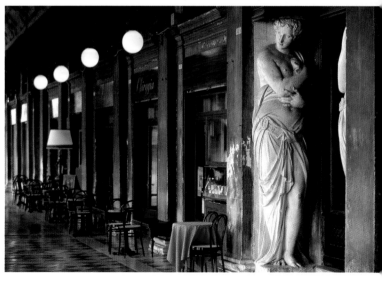

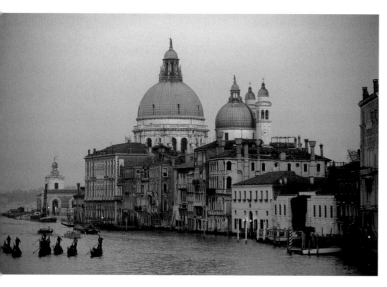

works by leading Venetian artists, but the
place where one can best understand the
complex evolution of this school of
painting is the Accademia. Its galleries,
which are divided into more than 30
rooms, depict the history of an unrivalled
and unique artistic experience that
extends from the Middle Ages to the dawn
of the modern age.

A short walk from the Accademia will
take you to the Zattere, from where you
can see the Giudecca beyond the broad
canal. From the sixteenth century
onwards, the position of this island made
it an ideal centre for entertainment and
leisure activities. Consequently, it soon
acquired wealthy villas, parks, charming
kitchen gardens and monasteries. After
Napoleon conquered the city, barracks,
prisons and working-class quarters grew
up there. Today the Giudecca, well off the
beaten track of mass tourism, is an ideal

122-123 These three photographs of the Rialto Bridge, St Mark's Square and the Bridge of Sighs are enough to make one realize how Venice becomes a kaleidoscopic labyrinth at night. Daylight is replaced by lights that differ in color, intensity and direction, so that the city seems to expand and contract like an indefinable dream.

124-125 Santa Maria della Salute viewed from the St Mark's Basin.

126-127 The fascinating profile of St Mark's Square seen from the Giudecca island at sunset.

128 St Mark's Square is truly a legendary place. The material reality of Venice merges with the myth that this city has embodied for centuries, and seeking its identity entails a journey into the world of the imaginary.

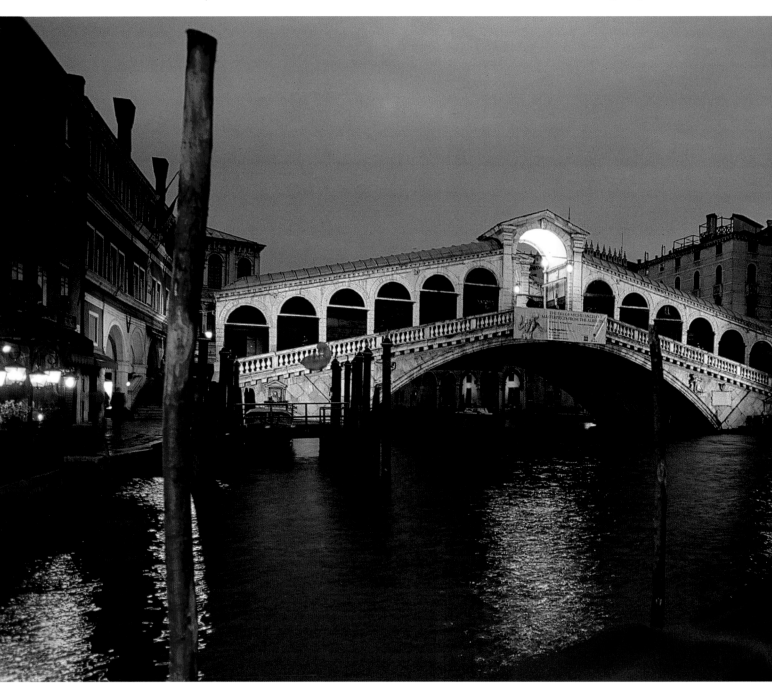

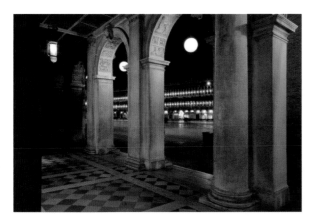

place to rest. From the Fondamenta delle Zitelle there is a stupendous view of the San Marco Basin, between the dome of the Salute Basilica and the campanile of San Giorgio Maggiore, in which Venice is simply radiant. You can enjoy the silence and linger in the light of the setting sun to watch the stones of St Mark's and the Doge's Palace magically turn to gold before that one final moment when the last ray of sun seems to pause and then

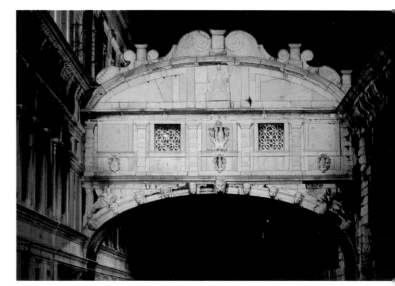

disappear beneath the horizon. Now, looking at the blackening shape of the city, suspended between the fiery, golden surfaces of air and water, a strange feeling of restlessness assails us, a sensation that the various identities we have so feverishly sought are nothing but masks. We have the impression that the city is still hidden behind masks, still concealing its true identity. And yet, perhaps it is precisely the elusive, impalpable nature of Venice that reveals its true essence as a resplendent creature of dreams.

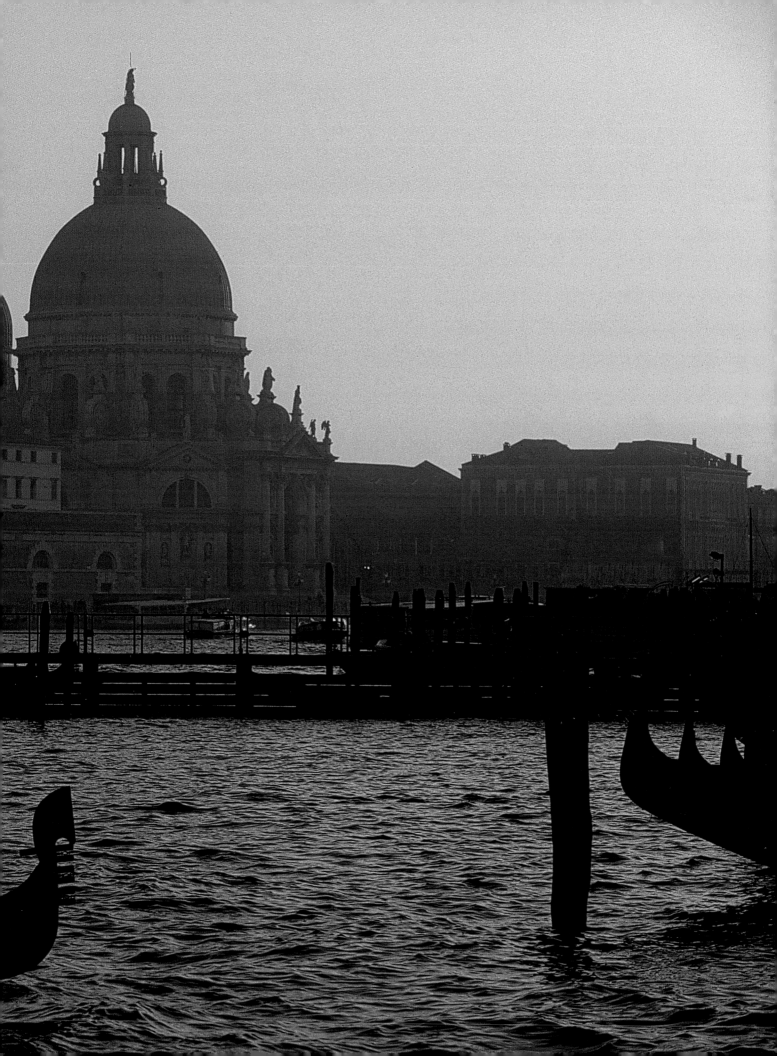

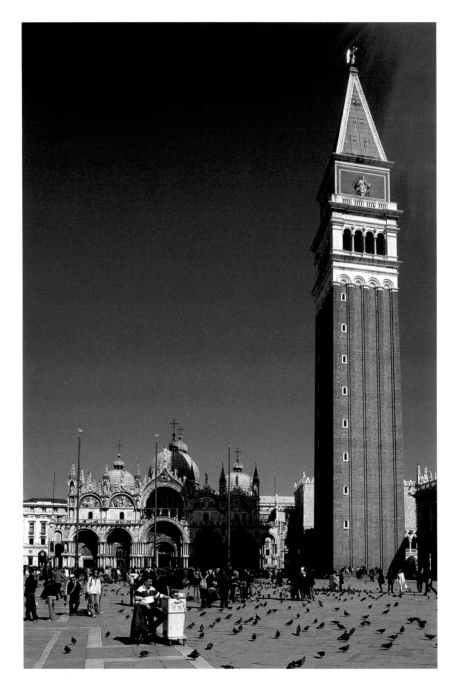

All the photographs in this book are by
Livio Bourbon / Archivio Priuli & Verlucca,
except the following: pages 9, 10-11, 14, 16,
17 top, 17 bottom, 18-19, 20, 20-21 by
Agenzia Fotografica Luisa Ricciarini - Milano;
pages 105 top, 115 top by
Antonio Attini / Archivio Priuli & Verlucca.

The collection «City of Art» is created by Fabio Bourbon.